FARFETCH
CURATES
ART

ASSOULINE

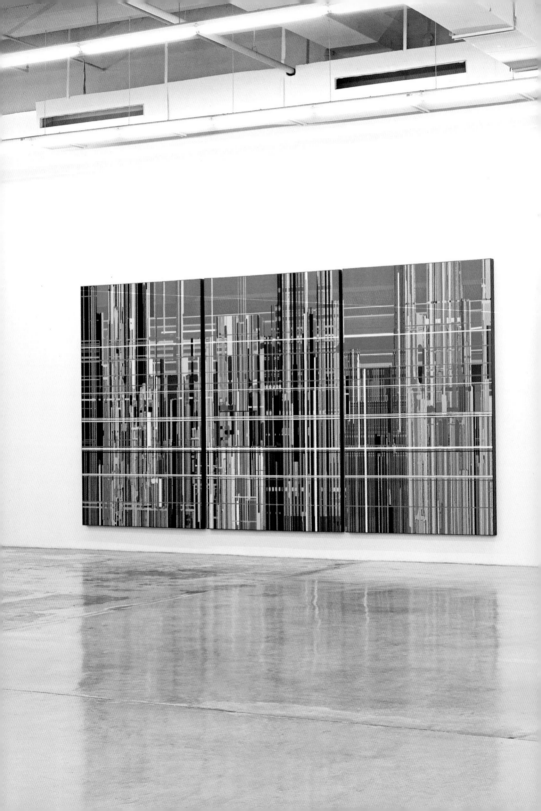

CONTENTS

Liu Wei, *Liberation No. 1,* 2013; oil on canvas; part of the exhibition *28 Chinese* at the Rubell Family Collection. See page 82 for the full feature.

FASHION AND ART: A DANGEROUS LIAISON BY STEFANO TONCHI

Art's mission throughout history has been to challenge opinion and pose uncomfortable questions – from the time when painters slyly subverted religious artworks commissioned by popes and kings with hidden political messages to our current era, which has seen Andy Warhol and Damien Hirst's incursions into pop culture and the appropriation of different media by many artists. The lives of artists are fascinating and surprising. They inhabit their own private worlds, reclusive in their studios or just inside their minds. But somehow they are able to sense any shift in the culture and reflect it in their work. They understand reality better than the rest of us. I often think that artists are the world's think tanks. Most of us just work and run and work and run – so we rely on artists to do all the thinking.

Fashion is without a doubt a form of commerce, but for years it has told stories of contemporary life, breaking taboos and conventions, not that differently from art. Fashion is the best and most immediate mirror of society, and you can read human history just by looking at what we have been wearing. Today, more than ever, it is a powerful component of contemporary culture, followed by millions of people in every country and under a variety of political regimes.

So it is very natural for artists to collaborate with designers and use fashion as a medium to deliver their images. It is also natural for many fashion designers to be inspired by artists; fashion people constantly look at art, they collect it in their houses and studios, they travel to faraway places to discover museums and visit collections. More and more frequently, it has become hard to see who inspires whom and where the separation line between art and fashion lies.

Not everyone is comfortable with this relationship, and some in the art world feel that fashion's appropriation of art has gone too far. I like to say that in the time we live in, there is too much fashionable art and too much arty fashion. Fashion and art are two distinct disciplines, but this book demonstrates that they can be showcased together while maintaining their individual integrity and specificity.

ARTIST IN RESIDENCE

Visiting an artist's studio is undoubtedly the most revealing and insightful way to get an understanding of both the art itself and the inspiration and rationale of its creator. We met Eli Sudbrack, one half of the prismatic art duo 'assume vivid astro focus' (avaf), in his vibrant Brooklyn studio:

After a decade working cross-continentally, Sudbrack and his Parisian partner Christophe Hamaide-Pierson's vivacious multidisciplinary canon now spans performance art (a cabaret- and transvestite-heavy demolition disco at **Deitch Projects** in New York), mixed media (a giant pair of inflatable thighs erupting from Oslo's **National Museum of Art**), painting, film, neon, and even fully functioning roller skating rinks. 'I just think you have to have an opportunity to be an artist,' Sudbrack says. 'So my belief from the beginning was that other people could actually "assume" assume vivid astro focus.'

avaf deliberately obfuscates authorship, constantly mutating the assumed working pseudonym. 'I started to create different combinations of the avaf initials for every show we worked on,' Sudbrack explains. Their exhibition titles are a dictionary-digging mash-up of hybrids, including: *absorb viral attack fantasy, a very*

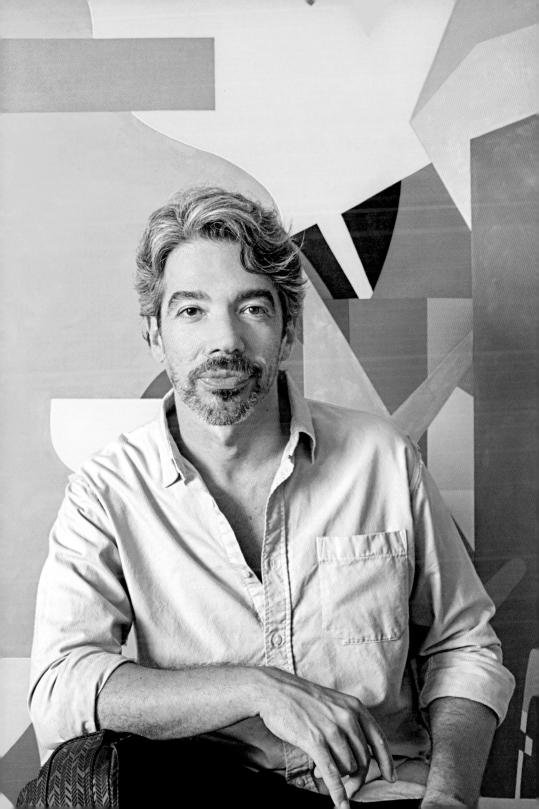

anxious feeling, *aqui volvemos adornos frivolos*, and *ancient vagrancy apollonian futurism*. 'We also created a project online where people can actually submit and create their own avaf combinations,' he continues. 'It became this very spontaneous collaborative work. Nowadays I have over five hundred different combinations.'

Audience immersion is essential to avaf's practice, and explosive colour, music, video, and floor-to-ceiling wallpapers draw the viewer into their chromatically celestial world. 'We can actually somehow make the viewer relax and give himself to the installation,' Sudbrack explains.

Their 2003 *Decals* project went one step further. 'We developed single images extracted from our wallpapers, and whenever a collector buys this "decal" they can decide how it is going to manifest in the real world. They can decide if it's going to be printed on Plexi or if it's going to be a sticker, mounted on foam, fifty feet or five inches big. One of our collectors, the shoemaker Ernesto Esposito, completely got the idea and he started "assuming" assume vivid astro focus with an exhibition in Naples. A friend of mine mentioned "Oh, I saw that exhibition of yours there," but we had never done a show in Naples, and I realised it was Ernesto. Later on we were invited to do an exhibition in Trento, Italy, but we couldn't commit, and we said that

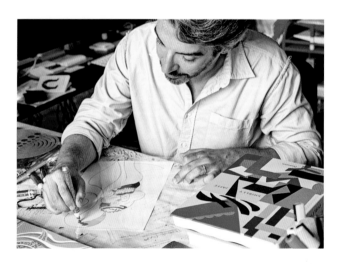

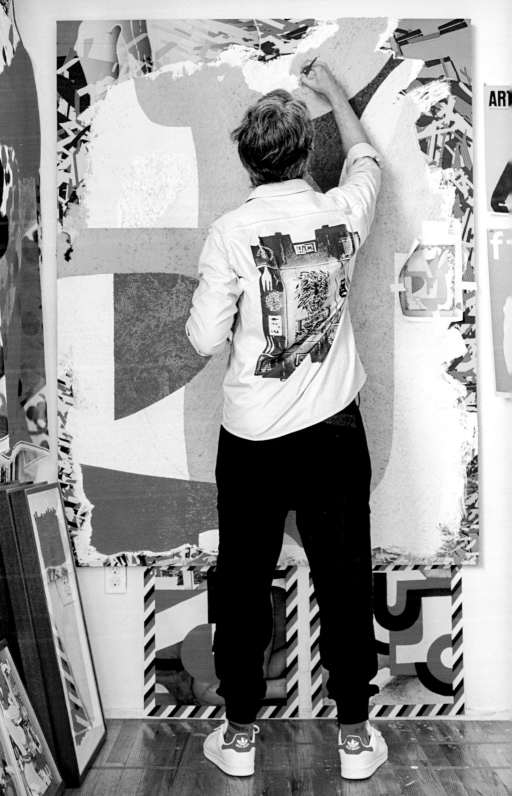

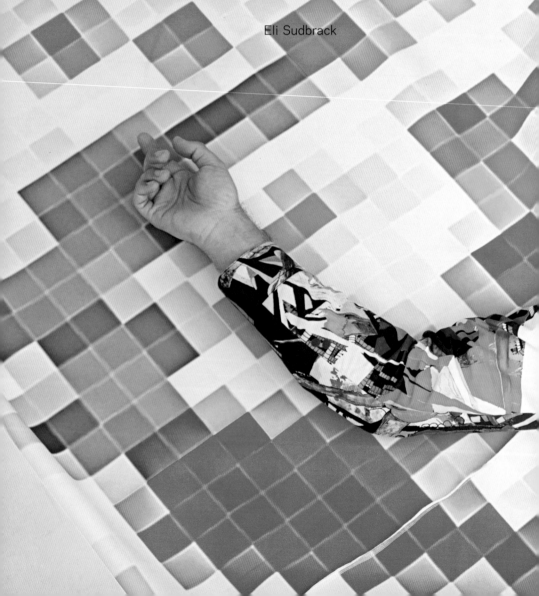

"Colour pulls the viewer in and makes them one with the installation.**"**

Eli Sudbrack

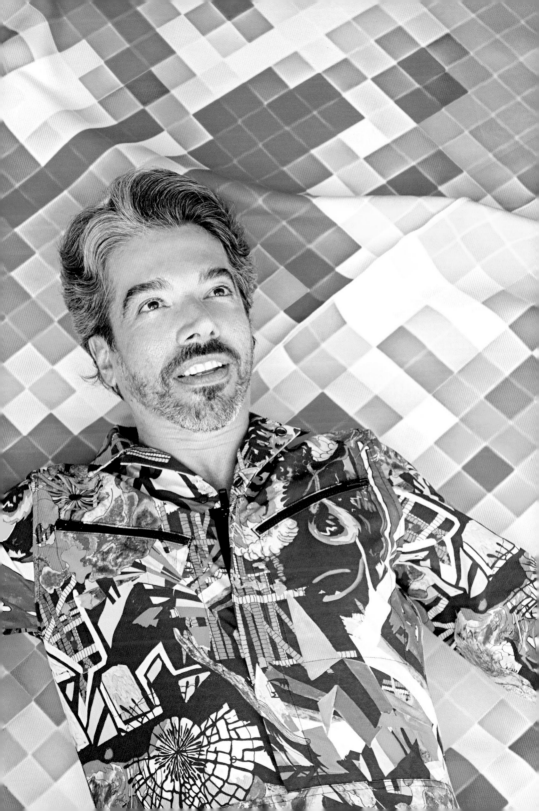

the only way we could get involved was if Ernesto created the installation. So that's what happened, he created a whole avaf installation.'

Sociopolitical, avaf's work explores hypocrisy, elitism, gender, gay rights, and sexuality. In one corner of Sudbrack's studio hangs a poster of General Idea's *Imagevirus* series (1989–91), a tiled image of the word 'AIDS' and a reconfiguration of Robert Indiana's 1966 *LOVE*. On another wall hangs avaf's own interpretation of this image, a mesmeric 3D wallpaper of four-letter words associated with the administration of George W. Bush, including '0911', 'Army', 'Iraq', 'Evil'. This vortex-like 3D wallpaper was originally plastered over the walls and ceilings of John Connelly Presents in New York in 2007.

Transgender imagery is a prominent motif. For their *adderall valium ativan focalin* show at The Suzanne Geiss Company in 2014, avaf exhibited brilliant cubist-style canvases of geometrically assembled male and female body parts. 'We've been working with the transgender image for a really long time. It became a symbol for us of demolition: destroying your own identity and reconstructing a new one.'

A book of avaf's ambisexual *Cyclops Trannies* caught the eye of Marc Jacobs, who collaborated with the duo for his final autumn/winter 2015 Marc by Marc Jacobs menswear collection. avaf's one-eyed creations adorn Marc by Marc Jacobs sweaters and bomber jackets, and they have counted Nike, Comme des Garçons, and Puma as collaborators as well.

For the duo, reconfiguration is a recurring practice. On one wall of Sudbrack's studio hangs a printed avaf canvas painted over with Rolotex and acrylic. On another is a canvas of jigsaw-like black, yellow, and fuchsia shards, an enlarged version of a small section of avaf digital wallpaper. 'Making a painting of a digital wallpaper that initially started as a hand-drawing before it was scanned into Illustrator or Photoshop was like doing a full circle,' Sudbrack says. 'Recreating a new identity not only for others but for ourselves is part of the process, and we're constantly looking back at our own imagery and reconfiguring it.'

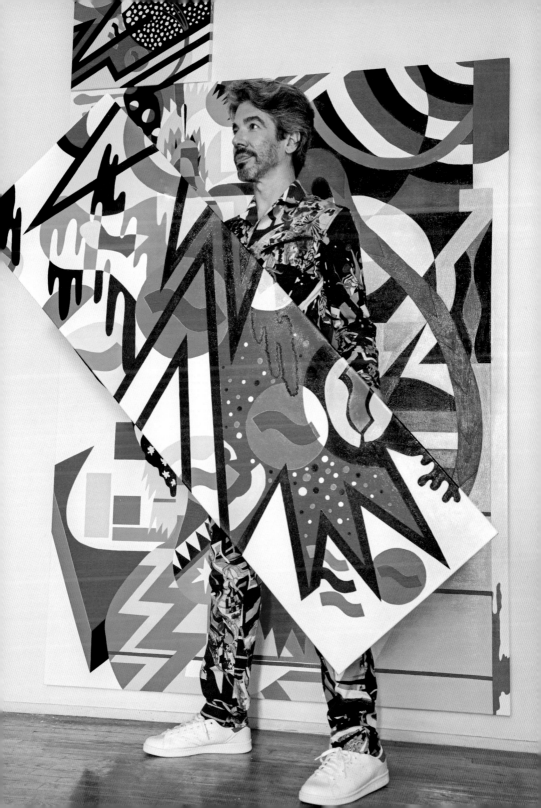

ELI'S U.S. ART PICKS

MASS MoCA

North Adams, Massachusetts

'MASS MoCA is an unbelievable space in a giant old factory. The museum has an amazing perspective on contemporary art, housing a permanent retrospective exhibition of one of my favourite artists, Sol LeWitt.'

 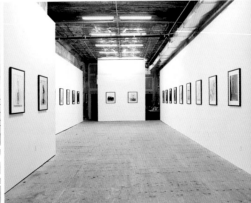

Sol LeWitt, installation view, Mass MoCA. Alice O'Malley, *Community of Elsewheres*, Participant Inc.

PARTICIPANT INC.

New York, New York

'It's always very challenging to have a non-profit initiative in the current New York art scene, which is so related to business and market. This is a wonderful non-profit gallery, which has previously shown work by the singer Kim Gordon and the eighties artist Greer Lankton.'

NOGUCHI MUSEUM

Long Island City, Queens, New York

'Noguchi was a Japanese-American sculptor who used to do these very minimalist sets, except he wasn't a minimalist. I don't know how to describe it, but the work is just very zen for me. I love going to the museum because it's so peaceful. There's no colour. It's very organic in a way, all white and shades of terracotta and black.'

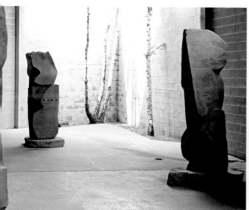 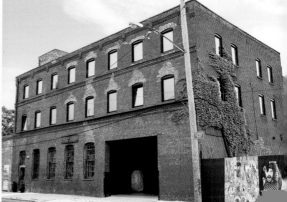

Installation view, the Noguchi Museum.

Pioneer Works.

PIONEER WORKS

Brooklyn, New York

'Pioneer Works is an amazing space run by the artist Dustin Yellin. I usually bike along the water all the way to South Brooklyn, which is one of my favourite neighbourhoods in the city, completely off from Manhattan and the art scene. They have residences and exhibitions; it's almost like a community.'

THE COLLECTORS

At an individual level, art often provides a very personal and genuine source of inspiration for fashion's creatives. A specific sculpture or a revolutionary art movement can influence a fashion collection, inspire a photographer, or illuminate an entire career. Farfetch spoke to five industry insiders to find out how their own art collections exert an influence over their creative lives:

ROKSANDA ILINCIC

Fashion designer, with Jeff Koons's Puppy Vase

I take inspiration from everything around me, whether it is art, architecture, magazines, or friends. These influences can be as direct as helping me to create a specific sleeve or to develop my particular mood or palette for the season. I love the innovative appropriation of and commentary on modern culture that contemporary pop artists, such as Jeff Koons, have mastered so well. I love the idea of creating something timeless and humorous out of the banal, whether it is metallic balloon animals or inflatable pool toys. I bought this Jeff Koons vase from a gallery in South Kensington called **Coskun.** I love the fact that it's a puppy. To me that conveys the feeling of love and something sweet, but it's also humorous. I move it around my home, from the living room to the bedroom, but at the moment I am trying to keep it safe from my four-year-old daughter.

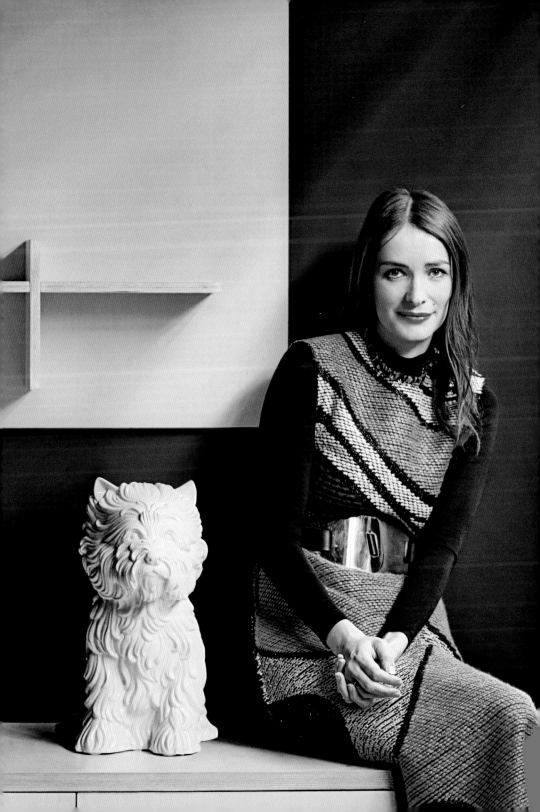

BRIAN BOLKE

Owner of **FORTY FIVE TEN,** *Dallas, with the artist's proof of a 2003 Viktor & Rolf exhibition poster by Inez and Vinoodh*

In college I was forced to take art history as part of my architecture studies. It was my first real exposure to the world outside of what was around me when I grew up. Then, in the mid-eighties, I saw Richard Avedon's show *In the American West* and got hooked on photography. Fashion photography captures the spirit of a moment in time. There is a passion in Inez and Vinoodh's work that defines them. I've met them a few times and they are incredibly warm people – they push boundaries but with a human touch. About a decade ago Viktor & Rolf sent this image, poster-size, to their clients as a Christmas card, and I immediately hung it on my office wall, where it lived for years. It was literally a part of my everyday life. When the artist's proof came up for auction, I had to have it. My husband, Faisal, bought it for me for my forty-fifth birthday.

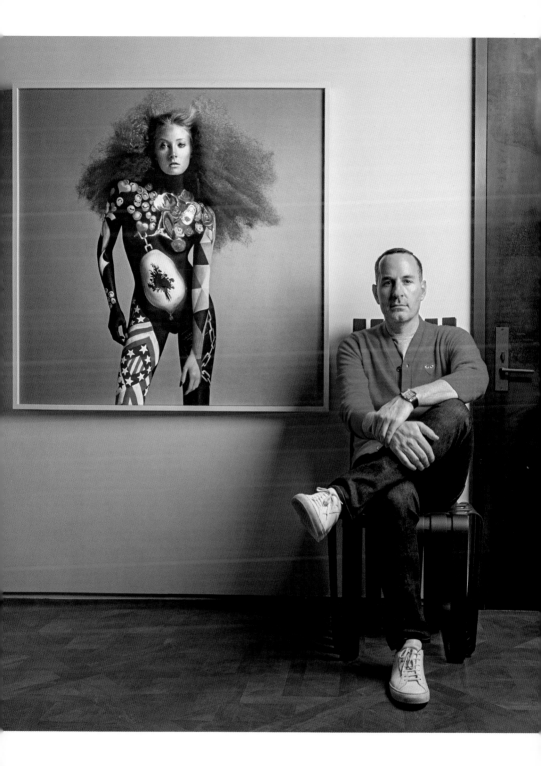

PASCALINE SMETS

Owner of **SMETS** *boutique and* **STEMS** *gallery, Brussels and Luxembourg, with Davide Balula's* Burnt Painting, Imprint of the Burnt Painting, *2013*

My childhood was filled with an array of museums, international exhibitions, galleries, and travel. Undoubtedly my encounters with gallery owners and artists proved to be a decisive factor, but one day, without really knowing it, I became smitten with the art world and never looked back! I love all the pieces in my collection. They all belong to a specific moment in my life and garner many emotions. A collection relates to personal history, anchors a past, and conditions a future. Davide Balula is an amazing artist, and his work is articulated around sound, electronic, and visual devices. I love the dialogue between the two elements of this piece, the solid plane of burnt wood and the imprint of the burnt wood on a canvas. These two elements work as mirror images that demonstrate negative and positive relationships, much like photography or printmaking.

CÉDRIC CHARLIER

Fashion designer, with Vincent Fournier's Space
Helmet, Extravehicular Visor Assembly, John F.
Kennedy Space Centre [NASA], Florida, U.S.A.,
2011; Untitled collage, *by Philippe Jusforgues;
and* La Fumeuse, *by Aurélie Gravas*

The prints in my autumn/winter 2015
collection take the form of broken stripes
and jolted lines, and are inspired by the
abstract and geometric work of the artist
Jonathan Lasker. (I kept a book by him
by my bed during the design process!)
In my studio I also have a photograph by
Vincent Fournier, and its space-travel
subject matter makes me think of infinite
journeys and new narratives, essential for
my creative inspiration.

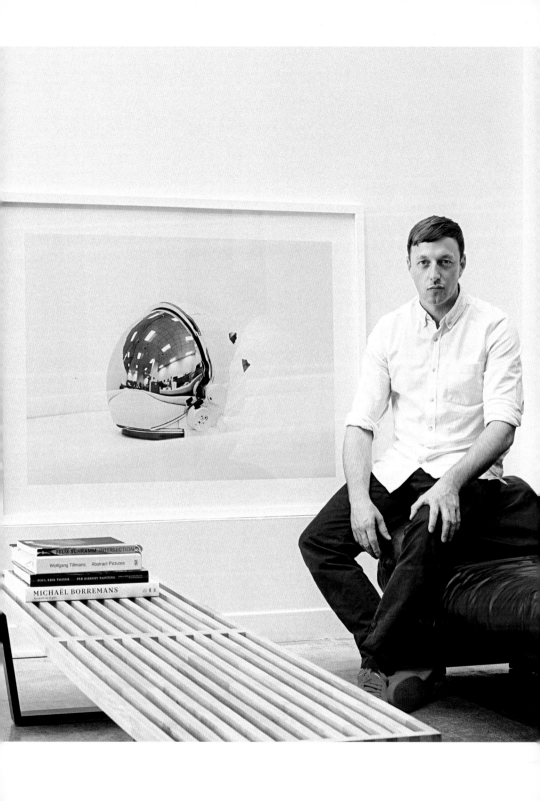

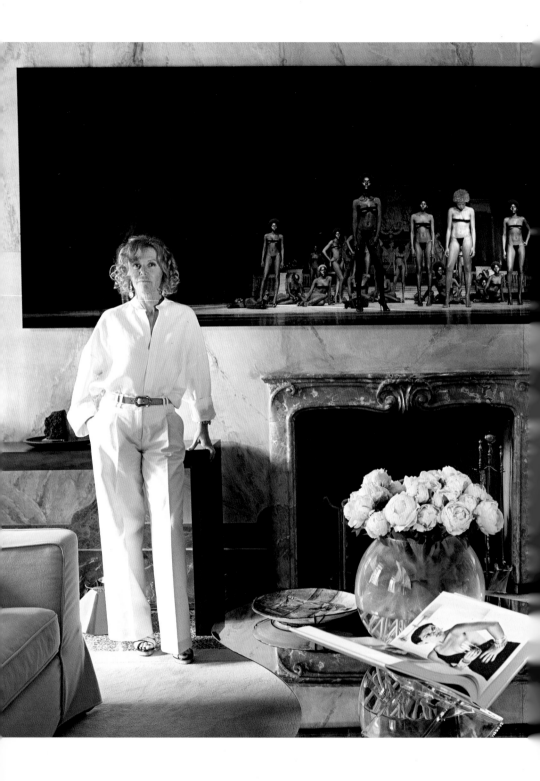

TIZIANA FAUSTI

Owner of **TIZIANA FAUSTI,** *Bergamo, with Vanessa Beecroft's VB48, performed at the Palazzo Ducale, Genoa, 2001*

I started collecting art more than twenty years ago, when I first started buying pieces from Enrico Castellani, Agostino Bonalumi, and Giuseppe Capogrossi, all absolute masters in modern art. Later on, my interest in contemporary art developed, and I bought works by Maurizio Cattelan, Rudolf Stingel, Christian Holstad, Yan Pei-Ming, and Piotr Uklański. My interest in art was inherited from my family. Firstly classical art, but curiosity and friendships led me deeper and deeper into the contemporary art world. What I like most about Vanessa Beecroft is her provocation of shape and perception. This performance, despite being quite static, is extremely sensual. I first saw an elegant and delicate print of this performance at a friend's house. I looked for a smaller piece but found this version, nearly four metres in length. It is magnificent in how imposing it is.

HIKARI'S GUIDE TO BUYING ART

With the rapid growth of art e-commerce and online auction sites, first steps into the world of purchasing art need not be the terrifying ordeal they might once have seemed. But it's always good to get advice from an expert. Step up Hikari Yokoyama of Paddle8, whom Farfetch has enlisted to share her tips on making initial forays into art ownership:

'Where I come from, art was something without meaning or gravitas,' explains Hikari Yokoyama, brand consultant, philanthropist, and founding member of the online art auction house Paddle8. 'It didn't seem important, though I was deeply attracted to museums in my hometown, Chicago, to album art on records, to magazines, to books on art – wherever I could find those touchpoints. However, I didn't know I wanted to work in art until I actually landed in it through the recommendation of one of my Columbia professors to intern with his gallery, Deitch Projects.'

Born in Japan and raised in Chicago, Hikari worked in New York before calling London her home. 'From an organisational perspective, the London scene seems to have more individualised non-profits shooting way above the mark, such as

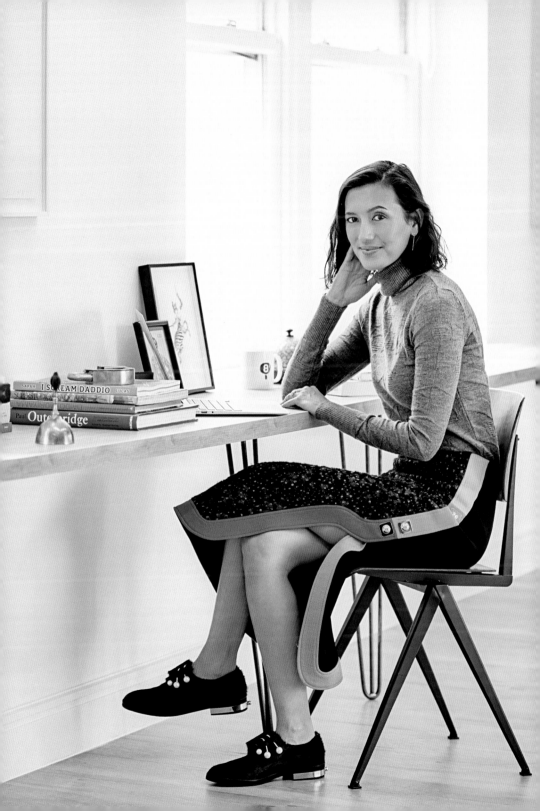

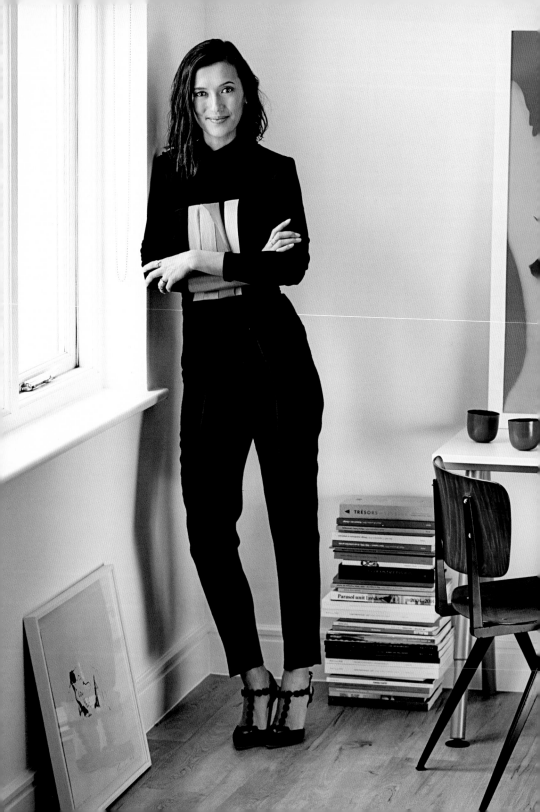

South London Gallery, which shows emerging artists alongside established artists, providing a launch pad to the individual art world,' Hikari says. 'The New York scene is far more vibrant and participatory, though, with a range or organisations focused on site-specific, out-of-the-white-walled-gallery-box kinds of projects. The non-profit **Creative Time** has engaged a vast audience with very thoughtful ways of integrating art into the fabric of the city, so that non-art-lovers become interested in interacting with ideas presented by the artist. In my mind contemporary art has been democratised (at least where I have lived), in the sense that if you are passionate, there are so many ways to get involved.'

Offering universal access to coveted art collectibles, Paddle8 is one of those democratising channels. 'It is a destination for collectors to build and refine their collections, combining the ease and efficiency of online shopping with the elegance and expertise of a traditional auction house,' explains the sophisticated art entrepreneur. 'You don't have to be part of an inner sanctum or on a gallery's waiting list to build a collection of compelling work by coveted artists.'

In December, Paddle8 presents an auction of works from the art collector Jean Pigozzi. His eclectic collection includes an erudite range of contemporary African art, spray paint portraits, and pieces by American painter Robert Ryman. 'It's a dazzling, colourful, ebullient collection, and there's a voyeuristic aspect to these single-owner sales that I love,' Hikari explains. Non-profit sales are also intrinsic to Paddle8's mission. Merging the fields of art and fashion, they have also partnered with the Council of Fashion Designers of America, inviting designers including Diane von Furstenberg, Reed Krakoff, and Prabal Gurung to select works by artists who have inspired them.

Keen to learn from her auctioneering expertise, we asked Hikari for some step-by-step advice to buying art for the first time:

1. There are many different paths to collecting, and no hard and fast rules. A good collection is made in an elusive yet personal way, akin to an epic spiritual journey to find oneself – like the *Odyssey* or *Siddartha*. Like the protagonists of these stories, the collector can expect to make mistakes, suffer anguish, feel disoriented or forsaken. However, a good collector is determined through patience, steadfastness, and strength of will to seek meaning through art. Collecting is a way of knowing oneself.

2. Collecting is an opportunity to indulge your idiosyncratic passions and innermost desires – even the bizarre ones. I've seen a collection based on spiritual objects and another focused on the male nude. I've seen some interested in conceptual materiality and another in big statements about life and death. It's not necessary to stick to a theme that can be summed up in a blurb, but in order to feel resonance with a piece of art, you must also understand yourself and what turns you on!

3. Do your own research. The art world is social and vibrant and full of opportunities to learn and to share. This can mean everything from the obvious – like reading critical reviews and going to see shows – to going to studios to understand process, talking to artists, talking to other collectors and to curators, attending talks and panel discussions, taking advantage of trained specialists at auction houses like Paddle8, poring over catalogues, and visiting international art events such as biennials and art fairs.

5. Always remain calm. There are always new artworks coming up for sale, so do not be rushed by others – take time for reflection and consideration. Wait until you have developed your eye to be able to make quick but calm decisions. If you're collecting for your passions, you will soon be able to make split-second judgments through what almost feels like intuition but is actually years of training – just like a baseball player cannot describe exactly how to hit the bat to the ball, he just does it.

" Collecting is a way of knowing oneself. "

4. Always be transparent and straight-forward in your dealings. Be upfront if you have a budget. Do not put a piece on hold and then not respond to emails. If you have made inquiries but then change your mind, let that person know (that's OK!). Every work of art is the final result of thought and labour. The artist is putting the work out, hoping that someone will cherish it. So be clear about where you are with your decision.

6. Don't be intimidated by the pre-sumed costs of collecting. There is art at every price point – you can buy a limited-edition zine, a print from Paddle8, an emerging work of art from NADA (the New Art Dealers Alliance), or a massive painting from **White Cube**. It is fine to inquire about prices. If the answer is $2,000,000 and you were thinking it might be $2,000, do not be discouraged! The first piece of art that I acquired was a limited edition signed folio by Christopher Wool for $250.

Damien Hirst, *Pardon*, 2012; silkscreen print with diamond dust, 36 x 36 cm, edition of 25, signed and numbered.

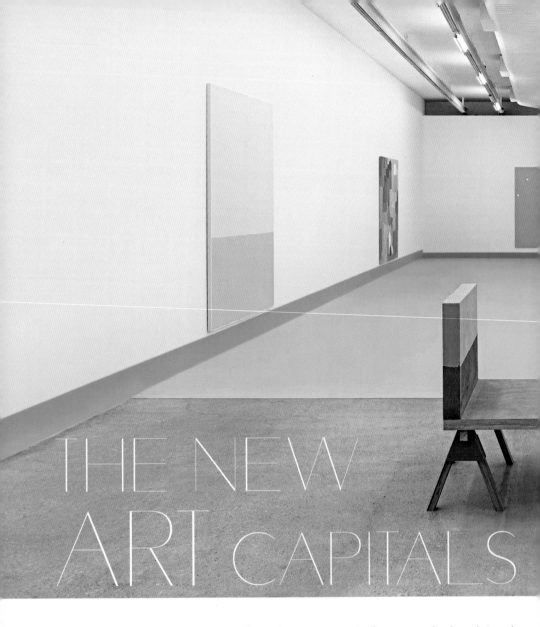

THE NEW
ART CAPITALS

With the international art market flourishing as never before, we asked acclaimed art writer Skye Sherwin to take a truly global view and report on five lesser-known cities that are fast emerging as art centres:

Until the twenty-first century, contemporary art typically meant Western art. In the past decade, a domino effect of global forces has made the art world truly

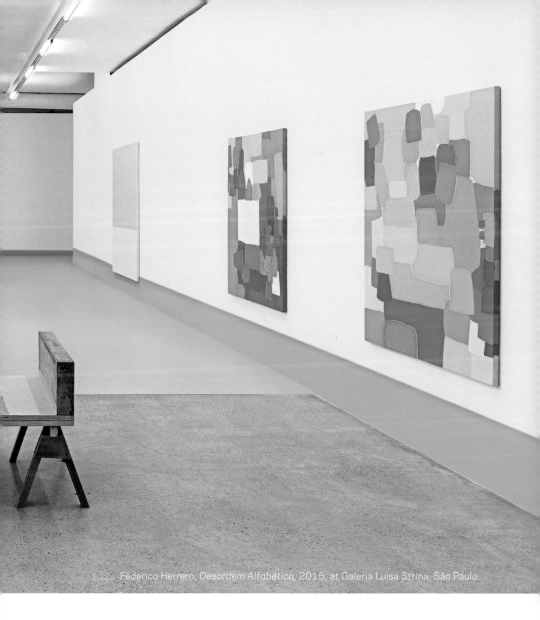

Federico Herrero, *Desordem Alfabética*, 2015, at Galeria Luisa Strina, São Paulo.

international. New biennials and art fairs have brought America's and Europe's cultural power brokers to far-flung destinations. Meanwhile, local scenes have flourished thanks to political and social change, the information revolution, and the all-important new money fuelling collectors in emerging markets. Forget London and New York: Major cities of continents as disparate as Asia, South America, and Africa are where some of the most compelling, vital art scenes are taking shape.

SÃO PAULO

São Paulo is Latin America's undisputed art capital. For bastions such as gallerist **Luisa Strina,** who started out during the military junta years, its recent cultural explosion must seem hard won. The Brazilian modernism of the 1960s – geometric abstraction with gorgeous colours and a political subtext heavily influenced by the local climate – was born of adversity under a government that prohibited public expression. The city's art biennial, the world's second oldest, was long boycotted by the international art community. Today, while the recent economic boom has fuelled new collectors, fresh generations of art stars are building on the city's rich art history and complicated sociopolitical legacies – from Adriana Varejão's disturbing and sensual interpretations of the country's colonial past to Marepe's politically charged pop-conceptualist take on local life and traditions. São Paulo's clutch of long-established dealers has been complemented by a rapidly growing gallery scene with young guns such as **Mendes Wood** and outposts from Western behemoths White Cube, Gagosian, and David Zwirner exhibiting at its major art fair, **SP-Arte.**

Clockwise from top: Galerie Barbara Thumm presents Diango Hernández at SP-Arte, 2015. Tonico Lemos Auad at SP-Arte, 2015. Adriana Varejão, *Vermelho Carnívoro [Carnivorous Red],* 2014; oil and plaster on canvas, 99 x 99 cm.

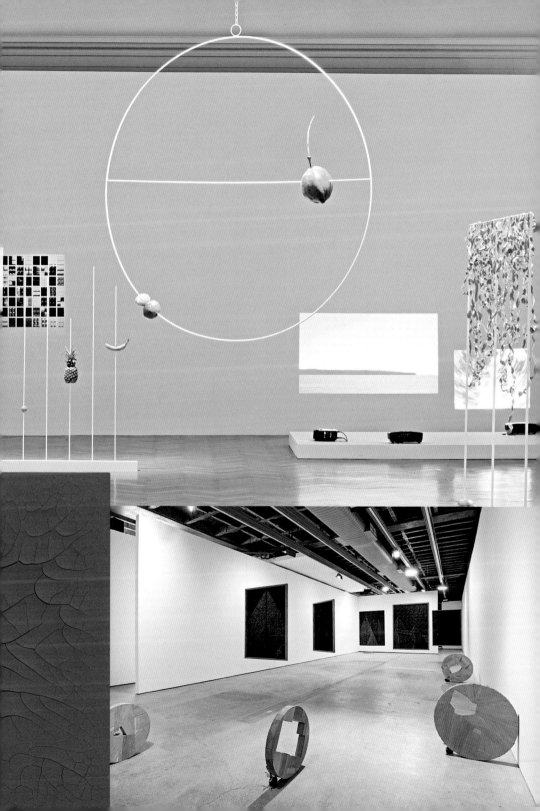

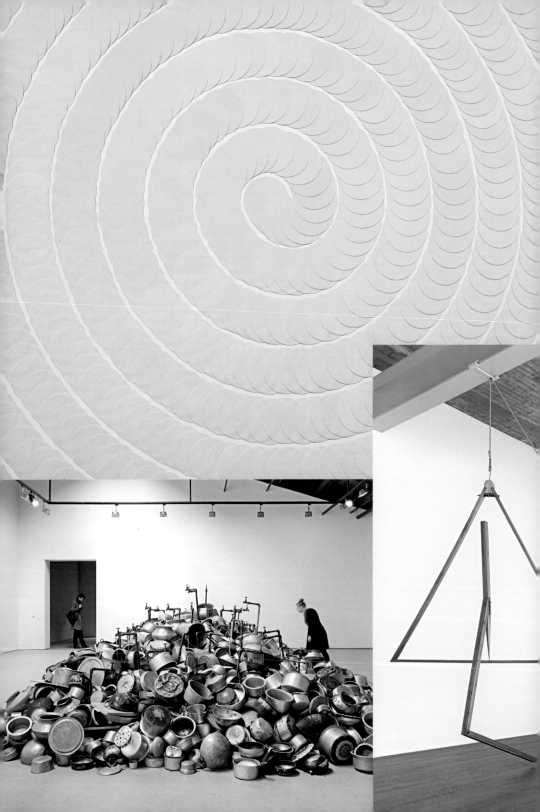

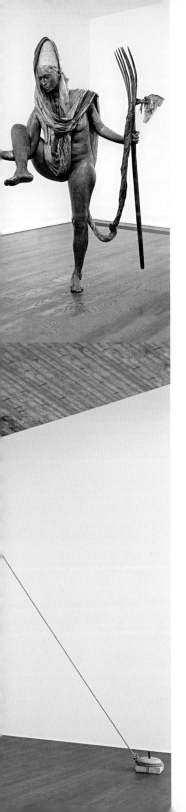

DELHI

Thanks to surging global interest in Indian art, work by Delhi's home-grown stars – such as Subodh Gupta (with his signature gleaming cooking pots), photographer Dayanita Singh, or the fantastical sculpture of Bharti Kher – regularly graces major museums and galleries worldwide. Keeping Delhi at art's bleeding edge are experimental think tanks such as **Sarai,** created by artists Raqs Media Collective, and **Khoj,** the key alternative project space that powers a performance festival and artist residencies. The radical thinking that fires such projects runs deep in Delhi's creative life. Since it became India's capital in 1947, its universities and cultural centres have been a hotbed for bohemian ideas. Born of this innovative outlook, today's teeming art world has fully embraced the city's urban sprawl, with 25 million inhabitants spread across towering new developments, urban villages, and Mughal remains. Luxury hotels and malls are the natural home for commercial galleries and private collections such as the **Devi Art Foundation.** Younger up-and-comers, however, are colonising the ancient and diverse **Lado Sarai village** where show openings are a regular cue for late-night street parties.

Clockwise from top left: Bharti Kher, *Virus II,* ongoing; detail. Bharti Kher, *The Messenger,* 2011; fibreglass, wooden rake, sari, resin, and roc, 188 x 136 x 84 cm. Bharti Kher, *three decimal points. of a minute. of a second. of a degree,* 2014; wood, metal, granite, and rope, dimensions variable. Subodh Gupta, *This is not a fountain,* 2011; old aluminium utensils, water, painted brass taps, PVC pipes, and motor, 165 x 483 x 785 cm.

BEIJING

Like China's economy, Beijing's contemporary art scene has established itself fast. In contrast to the apartment shows that dodged state censorship twenty years ago, the capital is now proudly home to glitzy auction houses and trailblazing project spaces. That Beijing's art scene has little desire to keep its head down has become clear with skyline-changing buildings, including German architect Ole Scheeren's latest landmark and **China Guardian**'s HQ – the auction house's complex of silvery pixel-like boxes a few streets from the Forbidden City. Local pioneer the **Long March Space** has provided a platform for radical new talents such as MadeIn Company since 2002, while exporting their vision to art fairs worldwide. Guy and Myriam Ullens, leading Belgian collectors of Chinese art, have further opened up the discussion, showing a dynamic mix of Chinese artists and international names at their art centre, **UCCA.** While most dealers congregate in Shanghai, Beijing is where the artists are. Their figurehead is, of course, activist and global hero Ai Weiwei, whose studio is a linchpin of **Caochangdi Art Village** on the city fringes. His temporary 2011 arrest, however, was a bracing reminder that Big Brother can sometimes do more than watch.

Clockwise from top: Xu Zhen, *Movement Field,* produced by MadeIn Company, 2013. UCCA entrance. Zhu Yu, installation view at Long March Space.

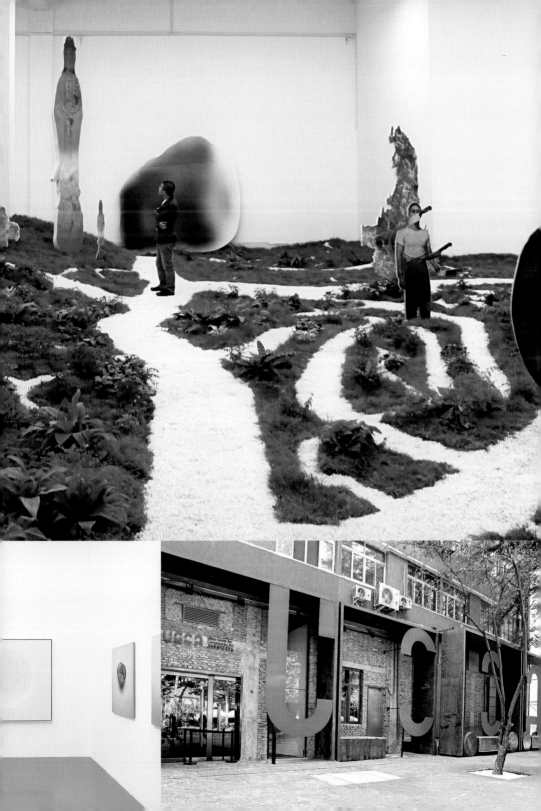

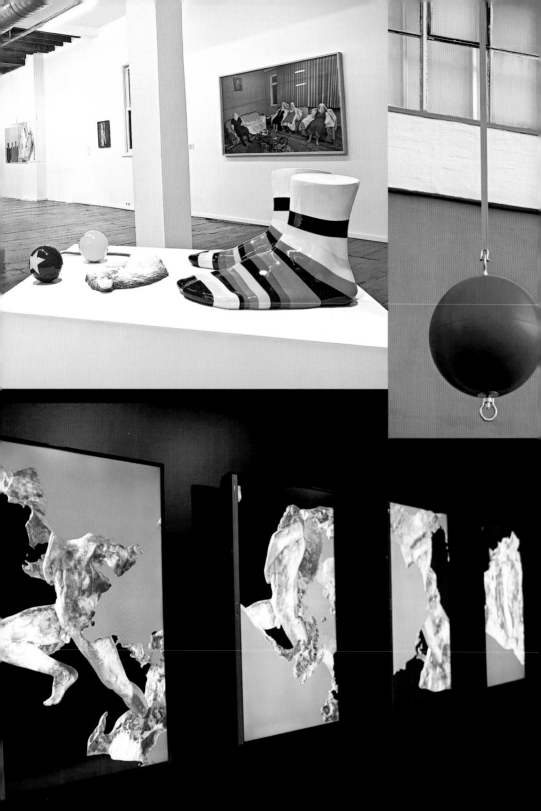

ISTANBUL

That international superstar curator Carolyn Christov-Bakargiev has steered the 2015 Istanbul biennial is testament to the city's status as a growing, if complicated, cultural hotspot, as rich in material as it is conflicted. At the previous event, artist Ayşe Erkmen placed a wrecking ball outside a soon-to-be-demolished exhibition space. It was slated to make way for more of the voracious urban development that sparked the Gezi Park protests that summer and the infamous response of the government. Though the city has hosted five separate art fairs in recent years – including the now well-established **Contemporary Istanbul** – with almost no government funding, Istanbul's indigenous art spaces depend on private investment and the unflagging commitment of local artists and curators. The corporate-backed IKSV, which runs the biennial, and **Arter,** which shows major international names alongside young Turkish talents, are linchpins of Istanbul's pioneering contemporary scene, while the artist-run **DEPO,** housed in an old tobacco warehouse, is dedicated to collaborative projects with artists throughout Anatolia.

Clockwise from top left: DEPO. Ayşe Erkmen, *bangbangbang,* 2014. Curator Carolyn Christov-Bakargiev. Contemporary Istanbul.

JOHANNESBURG

A gold rush town built by immigrant miners in 1886, Johannesburg is a tough, fragmented, unstable city where the crime rate keeps pace with its commercial success. Its shifting identity is a challenge artists have risen to again and again, from the iconic photographer David Goldblatt to the emerging star Robin Rhode, who gained recognition chalking his animations-cum-performances on the city's walls. Many of Jo'burg's native artists are long-established global stars, including William Kentridge, Candice Breitz, and Kendell Geers. In the past decade, thanks to new money and the West's growing interest in African art, its local scene is finally catching up. Since its inaugural 2008 edition, the **Joburg Art Fair** has become the major destination for collectors discovering artists from across the continent. Johannesburg itself has now birthed several generations of art and documentary snappers, thanks to Goldblatt's Market Photo Workshop and other high-profile photographers such as Jo Ractliffe. Though it still lacks a medium-specific gallery in the inner city to show off their talents, new art destinations are flourishing, such as **Braamfontein,** where you can discover work by historical innovators, and new names are exhibiting at the **Wits Art Museum** and leading commercial gallery **Stevenson.**

Clockwise from top left: Robin Rhode, *Chalk Bike,* 2015. Eve Tagny, *Skeem' Saka* exhibition opening, 2014. Robin Rhode, *Light Giver Light Taker,* 2015. Wits Art Museum.

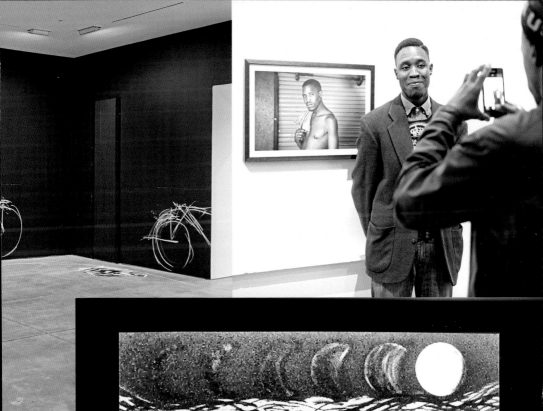

ART OFF THE BEATEN PATH

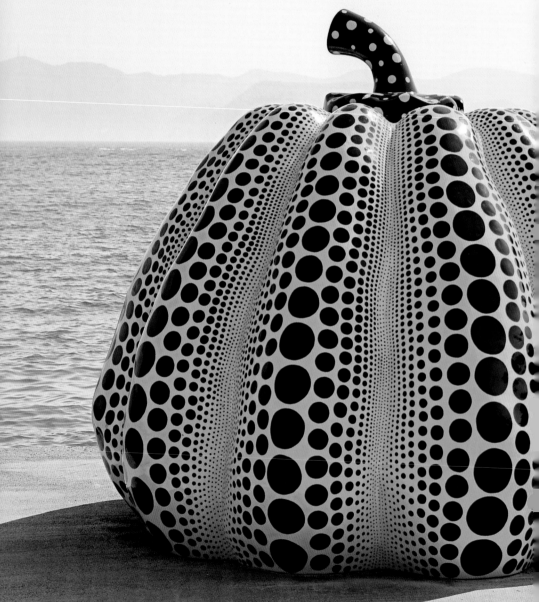

Appreciating art isn't all about blockbuster exhibitions at the world's major museums. In fact, some of the most engaging artworks can be found in the quieter corners of the globe, where the natural environment and the physical journey to get there become part of the experience. Here's the Farfetch edit of art's most diverting destinations:

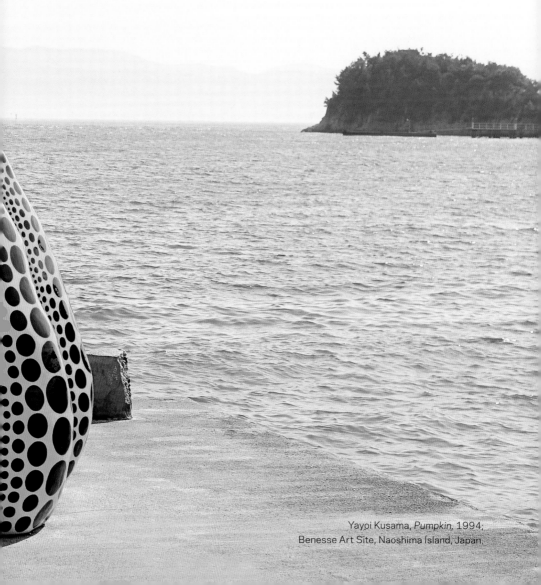

Yayoi Kusama, *Pumpkin*, 1994;
Benesse Art Site, Naoshima Island, Japan.

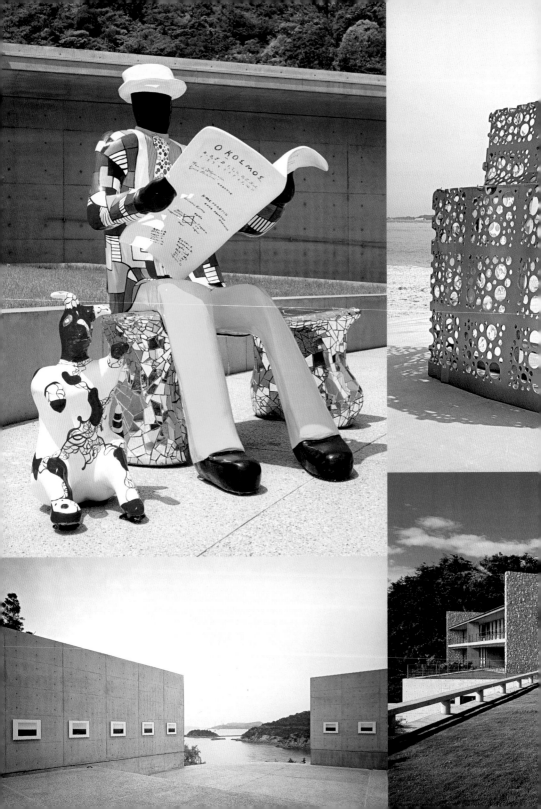

BENESSE ART SITE
Naoshima Island, Japan

With a population of over 100 million, there are few places in Japan that feel remote, but on the island of Naoshima, which sits in a channel two hundred kilometres west of Osaka, the Benesse Art Site offers a unique retreat with a peaceful atmosphere dedicated to the pondering and understanding of art on its visitors' own terms – feeling a million miles away from the bustle of urban Japan. The project, founded in the 1980s, gives artists the opportunity to exhibit contemporary artworks around Naoshima and the neighbouring islands. The underlying principle has always been to allow visitors to connect not only with the art itself but also with the island's beautiful surroundings and the local culture of the Seto Inland Sea region. Amongst the permanent collection you'll find Yayoi Kusama's iconic *Pumpkin* sitting incongruously at the end of a concrete jetty looking out to sea, like an alien life form. Guests can stay at architect Tadao Ando's **Benesse House** in the centre of the complex, and unwind in the zenlike serenity that it offers. After all, the name translates to English as 'living well'.

Clockwise from top left: Niki de Saint Phalle, *Le Banc*, 1989. Shinro Ohtake, *Shipyard Works: Stern with Hole*, 1990. Benesse House. Hiroshi Sugimoto, *Time Exposed.*

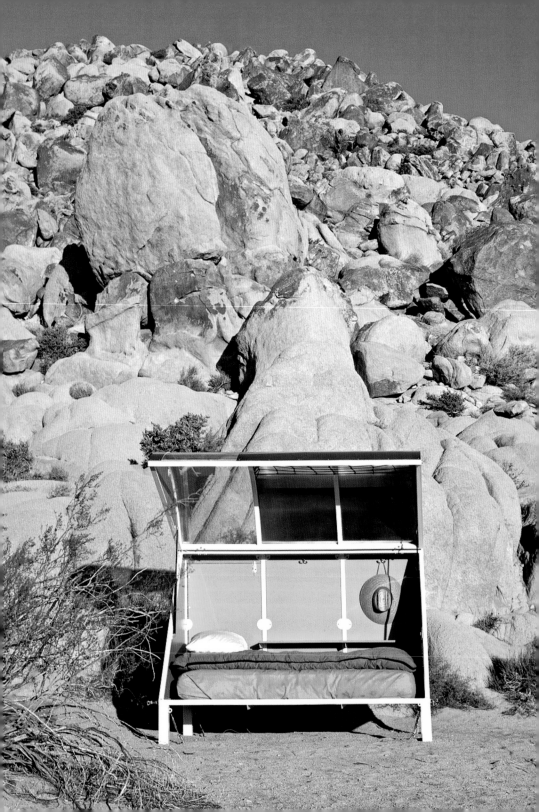

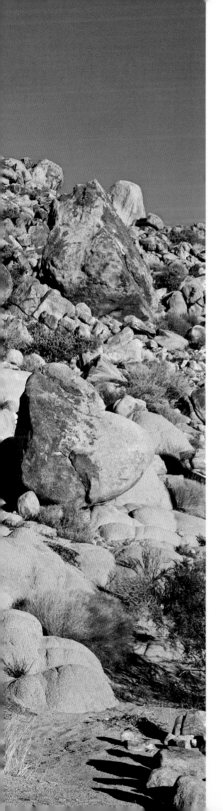

A-Z WEST
California, U.S.

Located on thirty-five acres of desert, close to California's Joshua Tree National Park, *A-Z West* by American artist Andrea Zittel is part art installation, part campsite, and part living experiment, where visitors can truly immerse themselves in the experience. The project, which began in 2000 but is ever evolving, is based around a series of seventeen temporary living shelters that reference modern station wagon cars but also the traditional covered wagons used by early North American pioneers. Throughout her work Zittel has constantly explored notions of self-sufficiency, autonomous living, and adaptability, so in *A-Z West*, the shelters are designed to transform mundane everyday actions, such as cooking and eating, sleeping and daily ablutions, into part of the art. Many of the shelters have been individually customised by Zittel's friends and collaborators, giving each a different ambience. Visitors to the site can either take official tours or actually spend vacations in the shelters, becoming a component of the experiment. The shelters are basic and snug, so anything above two people becomes a bit of a squeeze, but the desert location and its massive skies make the experience a true one-off.

BARBARA HEPWORTH MUSEUM AND SCULPTURE GARDEN

St Ives, Cornwall, U.K.

For a truly personal view on an artist regarded as one of the twentieth century's best sculptors, as well as for a refreshingly relaxed experience, a visit to St Ives, on the far south-western tip of England, is a must. Trewyn Studio and its sculpture garden, where Barbara Hepworth lived and worked from 1949 until her death in 1975, contains the largest group of her works on permanent display. The studio has been left relatively untouched, almost as if Hepworth has just popped out, giving the visitor genuine insight into the world she inhabited when the picturesque fishing town of St Ives was becoming a mecca for the world's abstract artists. The highlight is surely the garden, with exceptional pieces of Hepworth's sculpture dotted amid lush subtropical planting, where you can sit in its peaceful surrounds admiring the works and views across the town to the harbour, the Atlantic Ocean, and beyond.

Barbara Hepworth, *Four-Square (Walk Through)*, 1966.

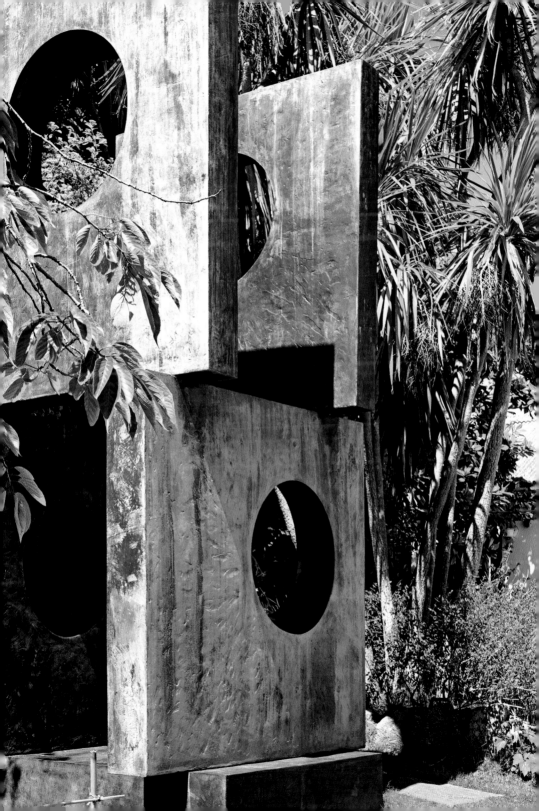

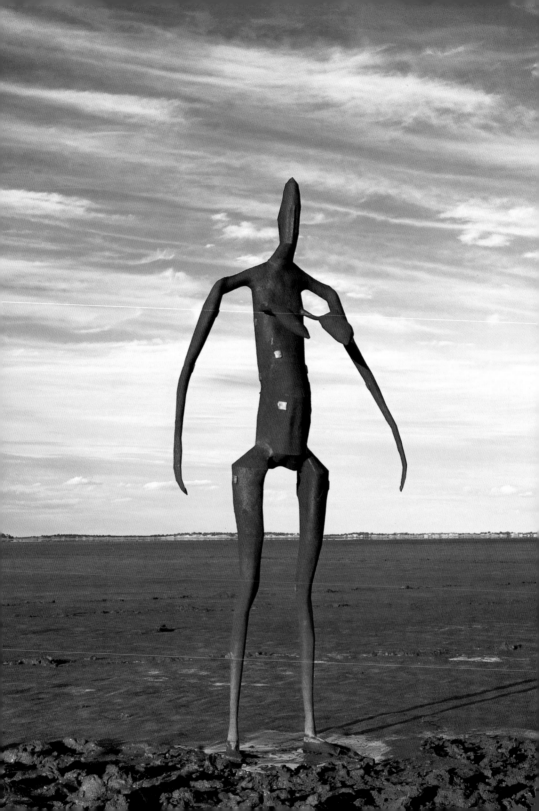

INSIDE AUSTRALIA
Lake Ballard, Western Australia, Australia

Turner Prize–winner Anthony Gormley's haunting sculptural figures have shown up in the most unusual places – on rooftops in London, on reclaimed Dutch marshland – but perhaps the most dramatic and remote location of all is across the bed of a dried salt lake in the Australian outback. Like ancient aboriginal hunter-gatherers frozen in time, fifty-one weathered metal figures stand motionless on the white crust of the 110-kilometre-long lakebed. The stylised figures themselves have a unique, deep-rooted connection to the local area as they were created from 3D body scans of fifty residents and visitors of Menzies, the nearest town to the lake, fifty kilometres away. Be warned though. Getting to Lake Ballard is not easy, involving a road trip of more than seven hundred kilometres east from Perth, and the only accommodations are in Menzies and at a lakeside campsite. But the spectacle that awaits the intrepid visitor is as arresting as anything the art world has produced.

THE CENTRO DE ARTE CONTEMPORÂNEA

Inhotim, Brumadinho, Brazil

In the 1990s, Bernardo Paz, a Brazilian mining magnate, began buying tracts of land surrounding his farm in an attempt to preserve the landscape from development. Before long he had created a botanical garden on the land – designed by his friend, the late landscape artist, Roberto Burle Marx – and in the early 2000s he was persuaded to start collecting contemporary art. As the art pieces began to grow in scale, the gardens themselves became the setting for the collection. In 2006, the garden opened to the public and now includes pieces by Brazilian and international greats, including Anish Kapoor, Doug Aitken, and Adriana Varejão. There are also beautifully designed pavilions dotted around the 500,000-acre site as well as a café and restaurant. Our tip for the best view of the entire site: Walk up to the hillside setting of Olafur Eliasson's kaleidoscopic telescope, which you can spin around to provide a unique if slightly disconcerting take on this tropical art theme park.

Hélio Oiticica, *Penetrável Magic Square No. 5 – De Luxe,* 1977.

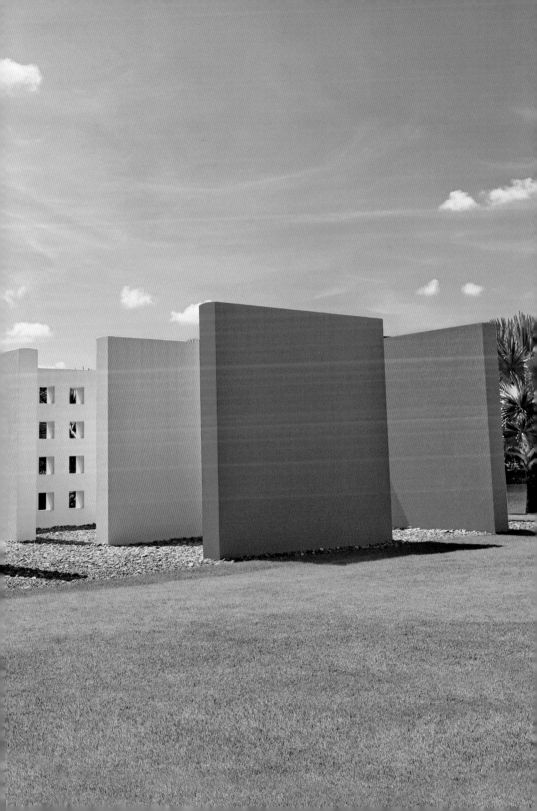

LA CONFIDENTIAL

Without a doubt, there is a new spirit of vitality and adventure permeating the Los Angeles art community as the city asserts itself as one of the world's great art centres. Young artists from all over the world are relocating there, colonising forgotten districts and helping to drive a new-found interest in its galleries, museums, art schools, and art fairs. So it's against this backdrop that we asked Emma Reeves, of MOCA (the Museum of Contemporary Art), one of LA's premier art institutions, to give us her highlights of the noteworthy people, places, and pieces helping to define the LA scene:

THE MUSEUM: THE BROAD

Grand Avenue, a wide north-south thoroughfare downtown, is home to several cultural institutions, including The Music Center, Walt Disney Concert Hall, and Redcat; **MOCA;** and even a thriving visual arts school. In 2012, several acres of well-landscaped public space known as **Grand Park** opened and has been constantly programmed with a wide range of activities ever since. The most anticipated addition to the Grand Avenue 'cultural corridor' is **The Broad** (pronounced to rhyme with 'road'), which sits next to the iconic Gehry-designed Disney Concert Hall and just over the road from MOCA. The Broad building – the work of architects Diller, Scofidio + Renfro – showcases revolving exhibitions from the private collection of Eli and Edythe Broad, which has deep holdings of some of the biggest names in the contemporary art world such as Jeff Koons, Jasper Johns, and Cindy Sherman. The building also serves as the storage location for almost the entire collection, and in an unusual gesture of transparency, the storage areas are also visible through an interior window. The Broads are deemed to be among the most powerful collectors in the world, and what better way to remind visitors of the scale of their collection than by making it all plainly visible?

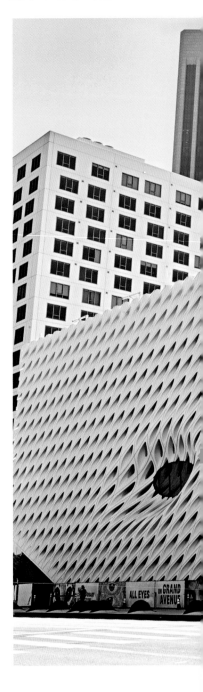

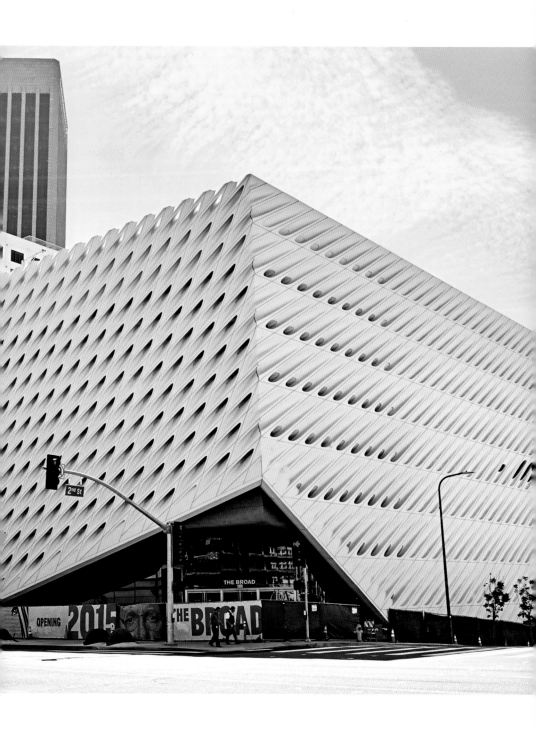

THE ARTIST: STERLING RUBY

Sterling Ruby came to study at the Art Center College of Design in Pasadena, California, under the tutelage of artist Richard Hawkins. He also spent time as a teaching assistant to Mike Kelley, another legendary teacher and artist whose reputation is inextricably linked to Los Angeles. Ruby was given a solo show at MOCA's West Hollywood location, and his installation *Supermax 2008* gave him the exposure needed to gain the attention of the global art community. The site-specific installation introduced a variety of elements and materials that have become synonymous with Ruby's work, including ceramics, large-scale poured urethane sculpture, collage, video, graffiti-like spray painting, and textiles. Ruby often cites a diverse range of sources and influences, including punk music, hip-hop culture, violence, and graffiti. In the world of fashion, he is also known for his collaborations with the designer Raf Simons, creative director at Christian Dior, who started collecting Ruby's work around a decade ago. Their friendship led to Ruby creating interiors for Simons's own label's Tokyo store in 2008, and in 2014 the pair's intense creative dialogue culminated in a full-fledged menswear collection for the Raf Simons label, while Simons's acclaimed debut couture collection for Dior included Ruby-inspired weaves.

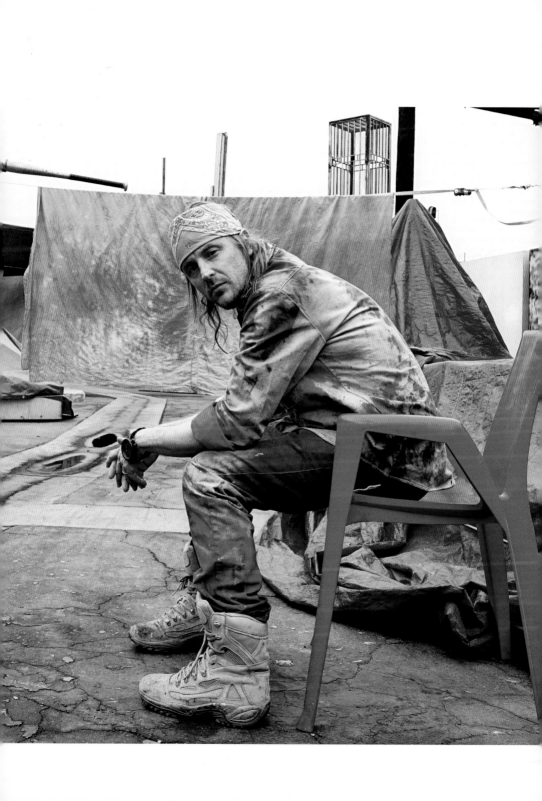

THE TRIP: DOUBLE NEGATIVE

The artist Michael Heizer is known to most for his artwork *Levitated Mass*, which is permanently on view at LACMA. Also known colloquially as *The Rock*, it was installed amidst much fanfare in 2012, as a specially chosen boulder was transported to LA. The original artwork was conceived in 1968 and is part of Heizer's ongoing commitment to an artistic movement known as Land Art, in which landscape and artwork are inextricably linked. Also conceived by Heizer in the late sixties is **Double Negative**, which is part of the permanent collection of MOCA. Situated about an hour north of downtown Las Vegas, this particular art pilgrimage is made easier now that *Double Negative* can be located on Google Maps, but the

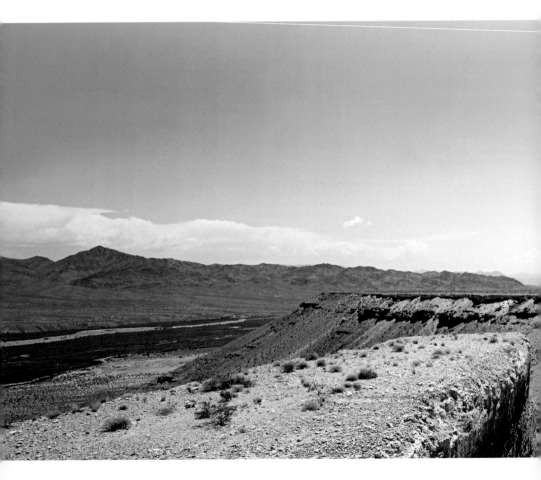

sense of discovery is not totally lost. It's still a thrill to slowly climb the dusty track to the top of a flattened hill known as the Mormon Mesa, unsure if you are really in the right place. Four-wheel-drive vehicles are advisable as the terrain is barren and windswept. Just as you begin to wonder if you're lost, the artwork suddenly reveals itself as a long trench of displaced earth that straddles either side of a natural canyon. Heizer intended for the work to be reclaimed by nature, and more than forty-five years later, erosion is doing its bit to make that happen.

Michael Heizer, *Double Negative*, 1969–70; 240,000-ton displacement of rhyolite and sandstone, Mormon Mesa, Overton, Nevada. The Museum of Contemporary Art, Los Angeles; gift of Virginia Dwan.

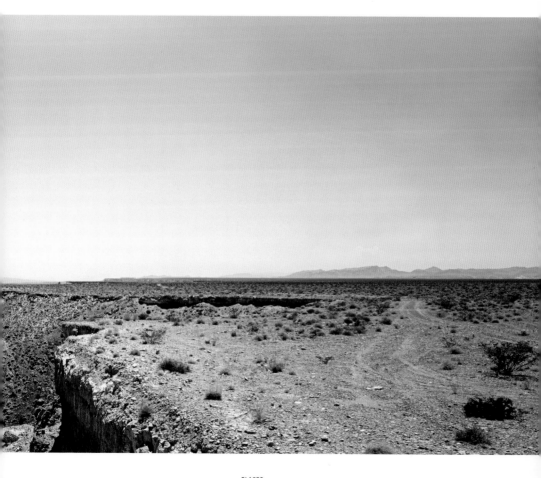

THE ANNIVERSARY: LACMA

Since 1961, **LACMA**, Los Angeles' largest art museum, has taken up several acres on Wilshire Boulevard in what is known as Miracle Mile. Housed in a building originally conceived by Brazilian architect Oscar Niemeyer, the museum has since amassed a network of buildings to hold its astonishing collection of Japanese, Islamic, and Latin American art, and is now undergoing a long-awaited redesign by Swiss architect Peter Zumthor. The museum, which holds more than 120,000 artworks, officially celebrated its fiftieth anniversary in April with a glittering party that raised more than $5 million and commanded over two hundred breathtaking donations, including pieces by Andy Warhol, David Hockney, and Claude Monet. But it is Chris Burden's 2008 external installation *Urban Light*, sited at the museum's entrance, that provides its most memorable prospect, securing swathes of Instagrammable adulation. Composed of 202 towering street lamps from the twenties and thirties, this forest of light glows from dusk till dawn, and is a subtle reminder of the glamour of Old Hollywood. No wonder they call it Miracle Mile.

Chris Burden, *Urban Light*, 2008; two hundred and two restored cast iron antique street lamps, 814.1 x 1743.7 x 1789.4 cm.

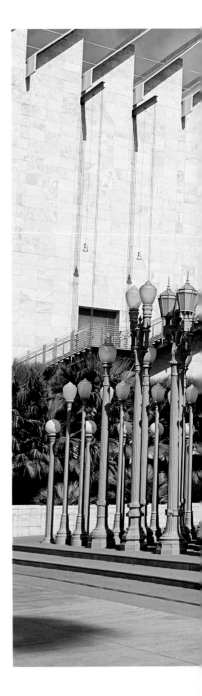

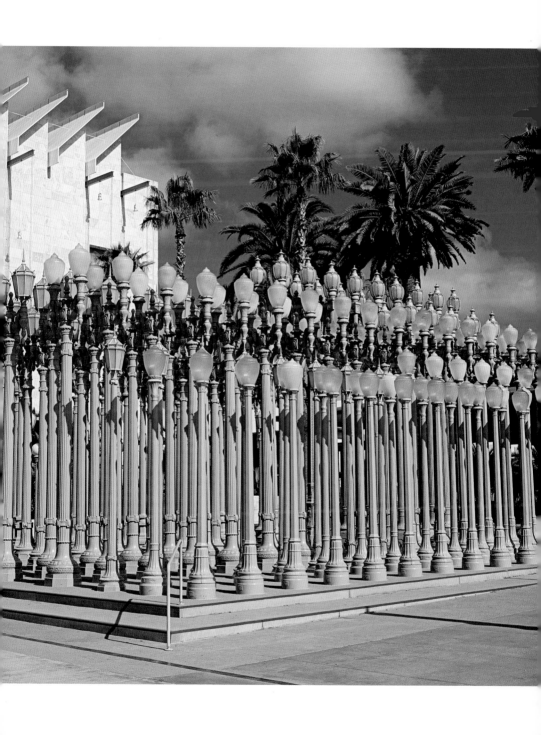

THE CURATOR: LANKA TATTERSALL

The trials and tribulations of LA's MOCA have been the subject of many column inches in the art press over the past few years. Directors have come and gone, artists have resigned and been reinstated to the board, fundraising has been an uphill struggle, and rumours of takeover bids have caused impassioned debate. But since spring 2014, Philippe Vergne, the director of the museum, has been gradually stabilising the institution. His tenure has already seen the appointment of a whole new roster of high fliers who are working resolutely to rebuild the iconic museum. They include chief curator Helen Molesworth, who made it an immediate priority to scour other world-class institutions for an assistant curator. Most paths led to Lanka Tattersall. Tattersall, an LA native, left a position she had held for four years, as assistant curator at the **MoMA** in New York, to return to her hometown. She cites a brief internship at MOCA when she was eighteen as one of the main reasons she wanted to become a museum curator. Tattersall is known for her well-formed connections within the emerging artist community in the States, as well as her deep understanding of art history, a combination that gives her the ideal foundation to help steer the museum in a new direction.

Nancy Rubins, *Chas' Stainless Steel, Mark Thompson's Airplane Parts, About 1000 Pounds of Stainless Steel Wire, Gagosian's Beverly Hills Space*, 2001–02.

THE STORE: JUST ONE EYE

Housed in an Art Deco building imbued with Hollywood glamour and said to be movie mogul Howard Hughes' former headquarters, this store is stocked with covetable designer clothes, shoes, and accessories, and specialises in incredible jewellery. Since opening in 2012, Just One Eye has also become known for bringing together artists and designers to produce exclusive products for the type of people who already have everything. In 2013, Nate Lowman painted canvases that were cut up to make twenty-one pairs of unique $25,000 Converse shoes. Prior to that, artist Damien Hirst collaborated with the Olsen sisters' label The Row on a capsule collection of twelve Nile crocodile rucksacks covered with signature Hirst pills and spots. The price tag on these was a colossal $55,000. In the boutique, these wearable artworks are surrounded by sculptures, paintings, photos, and carefully selected furniture, not to mention the other beautiful garments on sale. A visit to Just One Eye is a memorable experience only enhanced by a sense of adventure: You know you've really arrived as you pull up to the Romaine Street front door, just past a working cement factory, and a friendly doorman steps out to welcome you into the luxurious surroundings.

THE EVENT: PARIS PHOTO, LOS ANGELES

There are now hundreds of art fairs popping up annually around the globe, but Paris Photo Los Angeles - an offshoot of the august Paris-based fair - has to be one of the most memorable art fair experiences. Since 2013, the fair has taken up a long-weekend residency in the iconic New York City lot at Paramount Studios. The lot is five acres of buildings that replicate distinct areas of New York City such as SoHo, Greenwich Village, and the Lower East Side. Multiple films, advertisements, and music videos have been filmed here, and wandering around the streets, visiting the photo galleries and booksellers, is a perfect balance of entertainment, art appreciation, and commerce. In addition to the dozens of galleries spread around the streets and in the sound stages, the fair also hosts a robust series of artist discussions and book signings that encourage multiple visits within one season.

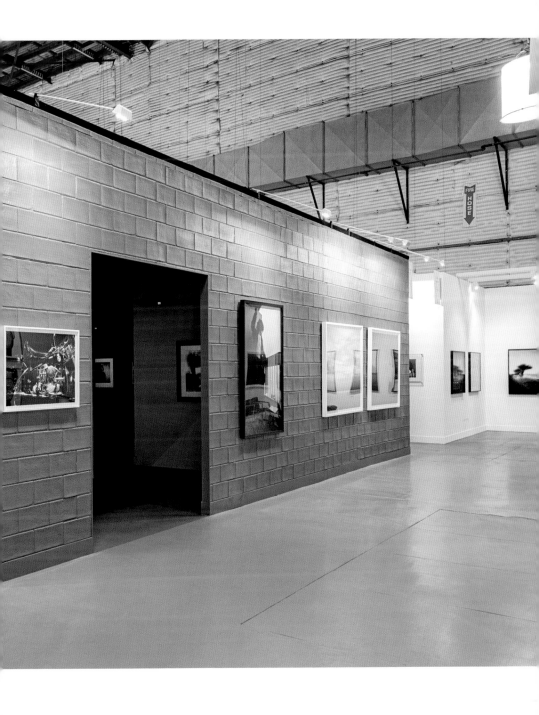

THE
VIRTUAL
AS REALITY

With the advent of digital technologies, the parameters within which artists work are continually evolving. One of the most significant new movements is Post-Internet Art, defined in 2006 by Marisa Olsen, one of its pioneers, as real-life work influenced by online realities. To keep abreast of this dynamic scene, we asked Grace Banks, the news and features editor of *Elephant Magazine,* for the inside track on the artists making the biggest waves:

The Internet has enabled one of the boldest art movements of the past hundred years. With the unprecedented conceptual powers technology offers, the post-Internet discourse allows artists to bring online matter into real life. And it's a movement that women steer. Social media, performance avatars, and URLs form a fresh new digital palette in which female artists address the metaphysical problems of existing creatively online. Together they're at the helm of a post-Internet movement that explores issues of authority, copyright, and authorship. Working with constantly evolving digital media, these artists present technology as an evolutionary stage in art and culture. Their proposition is clear: In an era of impulsive likes and one-click shares, art will be the vessel of change.

LEAH SCHRAGER
DIGITAL ANXIETY

Leah Schrager, *Photobooth Selfies #1*.
Previous pages: Leah Schrager, *Untitled*.

The knotty intersections of agency, gender, and status in the digital realm have caused artists to question the ownership of their online presence. Through paywall URLs, digital prints, and the exhibition *Body Anxiety*, Leah Schrager reclaims the virtual self, responding to the scrutiny women face in the post-Internet age.

What makes the Internet unique as a medium?
I think of it as another form of art, like sculpture. The web directly addresses feminist and artistic issues, such as ownership of image, the female body, censorship, hacking, beauty, intimacy, circulation, aesthetics, and connecting.

What's the concept behind Body Anxiety?
It's an attempt to point out that the digital art world is more likely to value women who are 'made art' over women who 'make art'. I call it Man Hands. If Man Hands place a woman in his art, she can become a valuable piece of art. But if Man Hands haven't touched her and she places herself in her art, she will be criticised.

Why are you pro-selfie?
The selfie is a form of self-portraiture in which the model owns legal and economic rights to her own image, thus obviating the role of Man Hands. It's about the implications of 'sharing' a woman's body and the violence of non-consent.

LESLIE KULESH
INTERNET APPAREL

Leslie Kulesh, *Prismatic Parcel (Nemo)*, 2015; synthetic material, neodymium, and cassiterite.

From webcams to dresses, charting the convergence of feminism, identity, and technology are key tropes for Leslie Kulesh. Her critical readings of celebrity are executed through prints, fluoro latex sculpture, and fashion. At once bold, bright, and beautiful, Kulesh's world is one in which women embrace digital narratives and flourish online.

Does the transiency of technology concern you?
I address this in my work *Baby BoBo*, a poster that can never be reproduced, as the digital files have been deleted. I'm looking at the toxic by-products of mobile technology.

How will T.A.G. help people navigate the Internet?
The T.A.G. Temporary Autonomous Girl capsule collection protects the wearer from electromagnetic frequencies. They also function as artworks. In 1983, Donna Haraway predicted: 'The cyborg is a matter of fiction and lived experience, that changes women's experience in the late twentieth century.' T.A.G. is the practice of a thoughtful approach to materials: It fuses the idea of cyborg and human.

How does technology activate your critique of celebrity?
My work comes from critical readings of everyone, from Ellen DeGeneres to Kim Kardashian. Technology allows us to play with performing a character, and I'm asking whether technology might bring our own authenticity into question.

ANN HIRSCH
PERFORMANCE AS IDENTITY

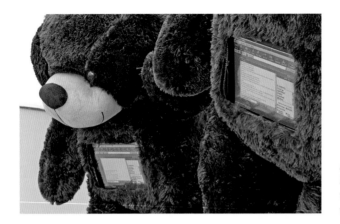

Ann Hirsch, *My Big Guy, My Little Man*, 2014; plush bears with customized iPad minis with censored app Twelve.

After her 2013 iTunes app Twelve – a simulation of a 1990s AOL chat room – was banned for explicit content, censorship has become a fundamental concern for Ann Hirsch. Working with teddy bears and iPads, she encourages the viewer to see art as the ultimate remedy for overpoliced online identities.

Twelve was censored. How did that feel?
It sucked. It was the first time I was censored, and it really hurt. It seemed hypocritical that *Lolita* is considered a masterpiece, but I write the same story from a young girl's point of view and it's too obscene for public. My hope with Twelve was that it would open the door for people to share their early online experiences, and how those being digital might change the way we view our sense of self.

Why do you consistently use your own online history?
I want to tell a compelling story about what intrigues me about my own past, showing the positive and negative aspects of growing up online.

What's the best thing about having the Internet as your medium?
It's a tool and an inspiration. It's done great things for gender issues. I also view it as its own subject matter.

KATE DURBIN
THE TANGIBLE SELF-PORTRAIT

Kate Durbin, *Hello Selfie.*

By manipulating popular web platforms such as Tumblr, Kate Durbin suggests that blog sites are one of the most exciting artistic tools of our time. Durbin is interested in the power of the digital self-portrait and in 2014 defined the term 'the girl gaze' – the importance of female empowerment in selfies.

You present Tumblr as a creative process. Why is it so interesting?
There's a fascinating collective aspect to Tumblr – the mutual sharing and ownership of images. You can witness art and culture being created before your very eyes.

Do you criticise digital self-portraiture in Hello, Selfie?
The piece takes place in a public space where a large group of female performers take selfies for an hour straight. I analyse a new form of passive-aggressive performance art, inspired by surveillance culture, Hello, Kitty!, and Apple products; the piece exists both IRL and URL.

Do selfies have the potential to become their own art form?
I look at Frida Kahlo's portraits, for example, as selfies – her selfies are beautiful and also vulnerable and filled with pain. Selfies are a way of loving and confronting the self. Now, for a girl to take a selfie is an act of artistic empowerment, a way to claim what I like to call 'the girl gaze'.

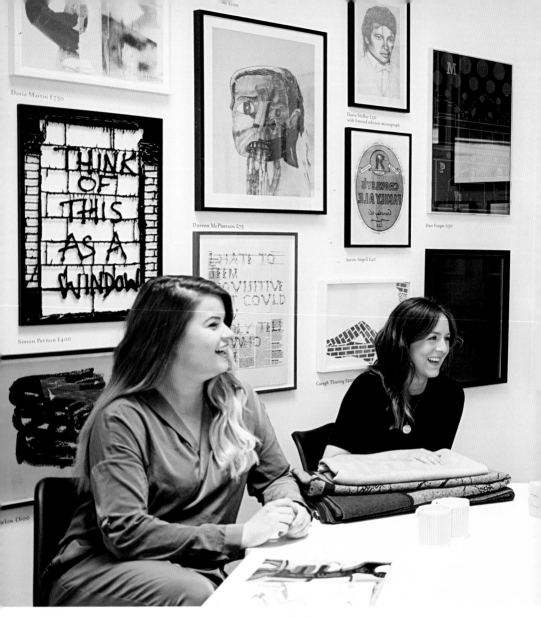

From left: Niamh Conneely, Jessica Vaughn, Joe Scotland, and Valeria Napoleone of House of Voltaire.

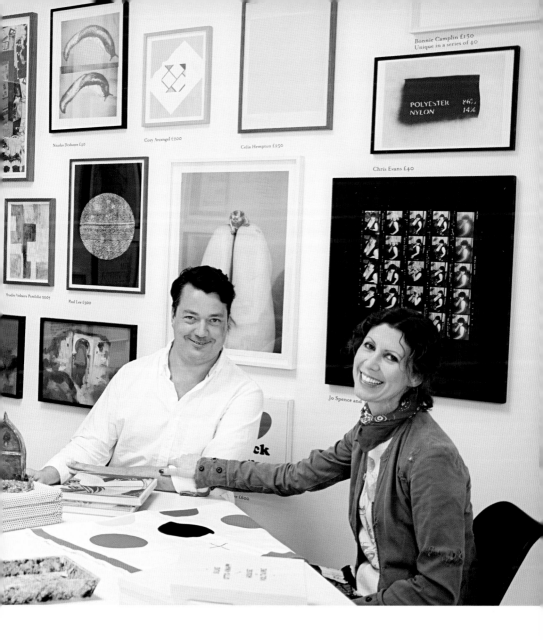

Bonnie Camplin £150
Unique in a series of 40

POLYESTER 86%
NYLON 14%

Nicolas Deshayes £40

Cory Arcangel £200

Celia Hempton £250

Chris Evans £40

Studio Voltaire Portfolio 2005

Paul Lee £300

Jo Spence and

THE COLLABORATORS

In a leafy South London suburb, Farfetch met the team behind **House of Voltaire,**
a revolutionary pop-up shop in London uniting eminent artists and fashion designers:

In 2010, designer Richard Nicoll and artist Linder Sterling created a sumptuous silk T-shirt and bandana for House of Voltaire, which was established to raise money for the Clapham-based non-profit art gallery **Studio Voltaire.** Emblazoned with provocative collages of images from seventies gay porno magazines, the clothing encapsulated the intention of the pop-up, which was to unite artists and designers in a bid to encourage innovative and experimental design.

'House of Voltaire is about giving freedom to artists and designers to collaborate and create outside of their comfort zones,' explains the renowned art collector Valeria Napoleone, the chair of Studio Voltaire's development committee. 'They are asked to embark on a journey, and that's when special things happen.'

Inspired by the pop-up shops opened by the Bloomsbury Group in 1913 and Keith Haring in 1986, House of Voltaire has commissioned unique collaborations between illustrious artists and fashion designers, including SIBLING and Jim Lambie, Chloé and Jenny Saville, Peter Pilotto and Francis Upritchard, and Simone Rocha and Sonic Youth frontwoman Kim Gordon. 'Enabling Simone and Kim to work together was a dream,' says Joe Scotland, director of Studio Voltaire. 'Their approach to the project was very interesting. I had expected them to work on a piece of clothing for the store; instead they produced a stunning photographic edition.'

With works ranging from £1 to £40,000, House of Voltaire encourages inclusivity. 'I think a successful artist is one who touches people on many levels,' Napoleone explains. 'It is important for all people to be exposed on one level or another to contemporary art.' The team's democratic standpoint is reflected in the traditional shopkeeper's uniforms that are issued to eager and revered volunteer shop staff, including *The Gentlewoman*'s editor-in-chief, Penny Martin, actor Russell Tovey, and Mark Francis, director of Gagosian Gallery in London. Wearing identical brown coats or hand-printed aprons by Laura Spring, the uniforms instil a sense of equality, not unlike the white lab coats worn by the creative team at Maison Margiela.

In December 2015, House of Voltaire will present a pop-up shop at **NADA** art fair in Miami (an organisation with an aligned approach to supporting young artists) with the always-covetable pieces on sale being created by the likes of Marc Camille Chaimowicz, David Noonan, and Turner Prize–winner Duncan Campbell. The team

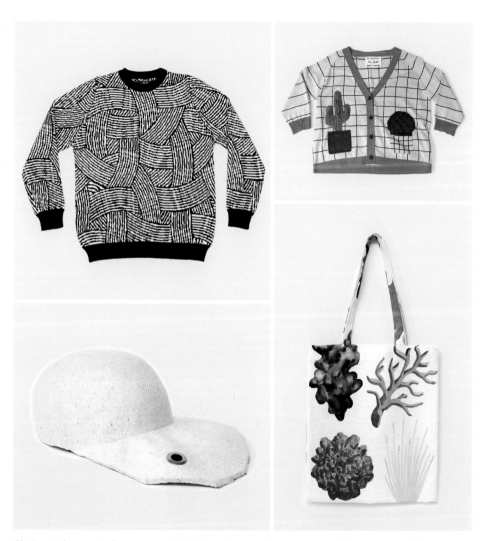

Clockwise from top left: Jumper by SIBLING and Jim Lambie; cardigan by Peter Jensen and Ella Kruglyanskaya; bag by April Crichton and Nicolas Party; cap by Noel Stewart and Alexandre da Cunha.

is also working with American artist Nicole Eisenman, who exhibited huge plaster sculptures at Studio Voltaire in 2012, on an exclusive woodcut print. 'House of Voltaire is like a family, and we have fun supporting each other,' Napoleone says. 'It's kind of like being part of a big party.'

WE ARE

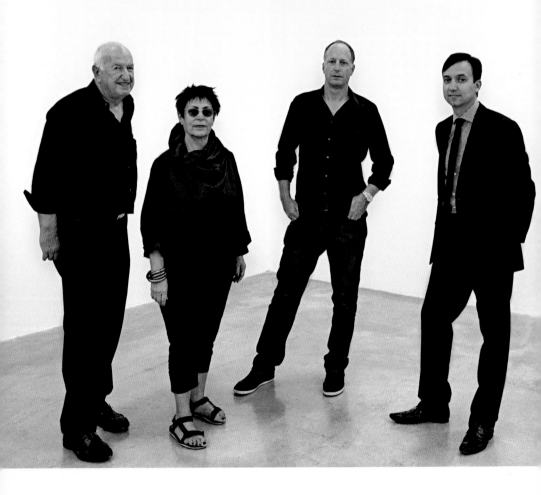

FAMILY

The **Rubell Family Collection** is the most important institution in a Miami art scene that has exploded in the past two decades. But what's the story behind this pioneering gallery, and how has one family attained and then maintained a place at American art's top table? Farfetch spoke directly to the Rubells to find out how their collective and individual personalities influence their approach to buying art:

Art seems to be woven into the DNA of the Rubell family. From its senior members right through to its most recent additions, there's an innate passion for the subject, a natural understanding of its mechanics, and an intimate and very personal grasp

Left to right: Don, Mera, and Jason Rubell and Collection Director Juan Roselione-Valadez.

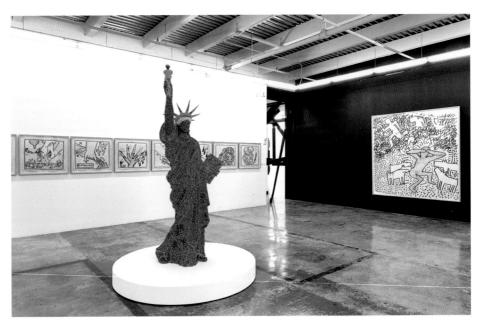

Keith Haring (collaboration with LA II), *Statue of Liberty*, 1982; acrylic and enamel on fiberglass with black light, 241.3 x 88.9 x 35.6 cm. *Opposite:* Zhu Jinshi, *Boat*, 2012; Xuan paper, bamboo, and cotton thread, 1500 x 350 x 420 cm.

of its culture. The grandees of this dynasty are Mera and Don, the husband and wife team whose dedication to collecting has spurred their rise to the helm of one of America's – if not the world's – preeminent private art collections.

Both native New Yorkers (Don's brother, Steve, founded the city's storied nightclub Studio 54), the couple's first small forays into art began in 1964, buying up pieces from up-and-coming artists. But a serendipitous encounter with a then-unknown Keith Haring in 1981 represents a key moment in their transition to becoming serious collectors. They liked Haring and his graffiti-like work so much they bought his exhibition at Manhattan's Mudd Club almost in its entirety.

'We had an incredibly special relationship with him, and we bought the first work he sold as well as the last work he sold,' says Don of the ensuing relationship with Haring. The gradual and studious method in which they followed this with the purchase of works by America's emerging superstars cemented a position in the country's art inner circle.

It's truly a family affair, with daughter Jennifer now an artist herself and son Jason very much a part of the collecting team that works like an efficient machine. Each of

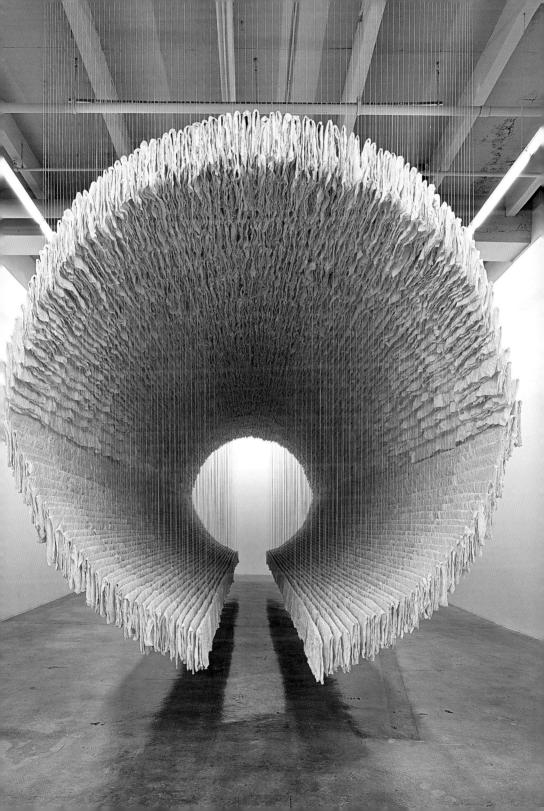

the key trio of Don, Mera, and Jason represents a critical cog within its workings, bringing a different skill and perspective to the buying process.

'We never approach it as an individual. The acquisition process quite often requires the physical presence of all three of us in front of the artwork. A consensus among us is paramount to our collecting,' explains Mera of the partnership, which is perhaps a wise approach, as both husband and wife admit to having very different personality traits and attitudes toward ownership of possessions, art or otherwise.

'It's definitely passion, definitely not with any consideration of the economics of collection,' says Don, while his wife talks of a natural reticence to amassing objects, suggesting that the very notion of collecting makes her anxious. A natural balance between Don's slightly gung-ho and spontaneous decision-making and Mera's more reserved and strategic but equally passionate approach is probably the key to their ongoing success.

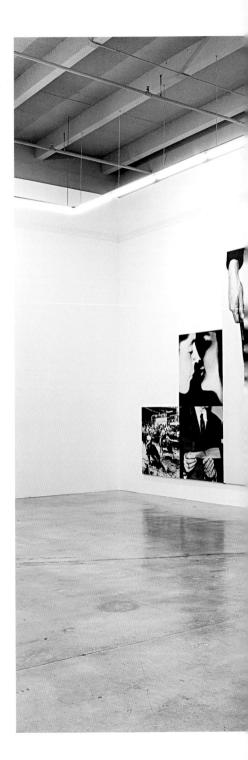

John Baldessari, *Stake: Art is Food for Thought and Food Costs Money,* 1985; black-and-white photographs, color photograph, and acrylic paint on canvas, 365.8 x 1219.2 cm.

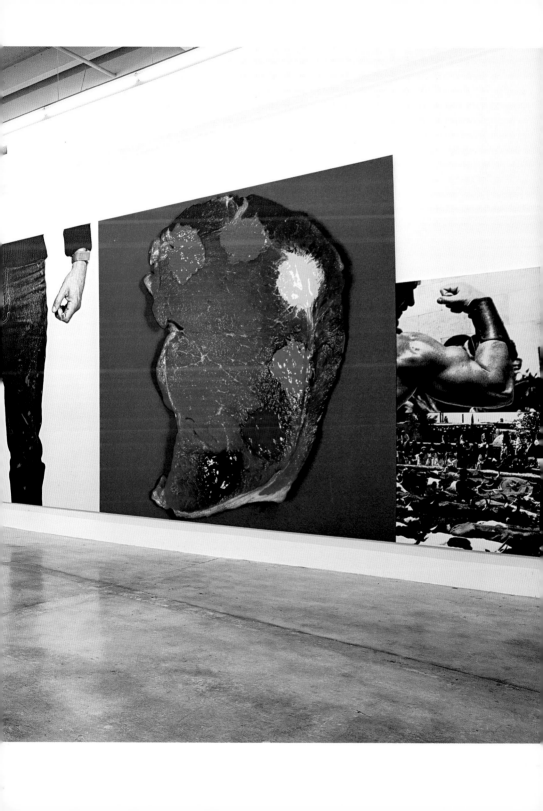

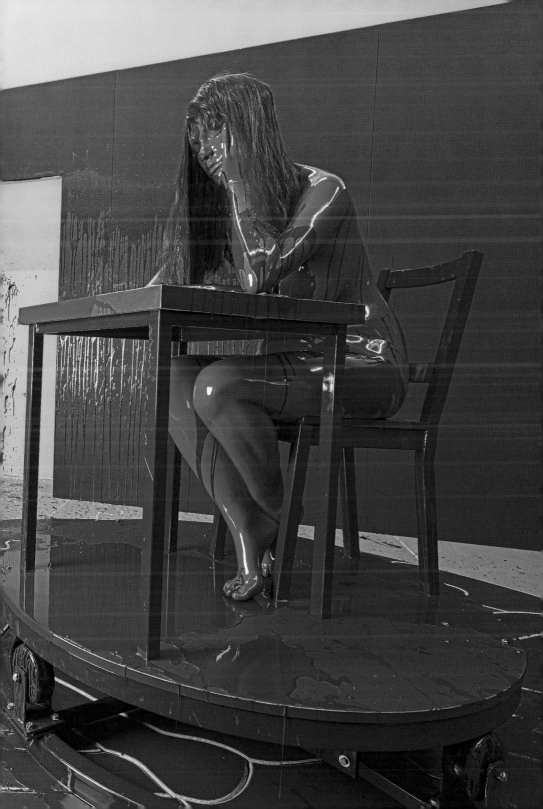

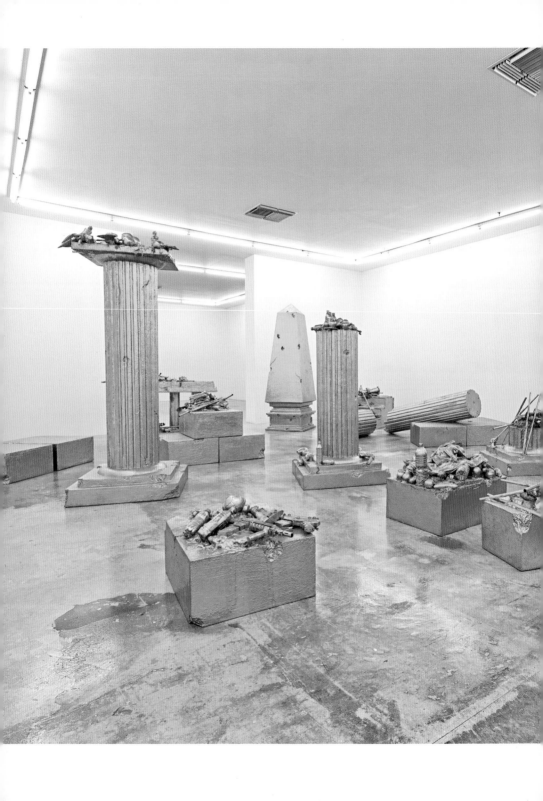

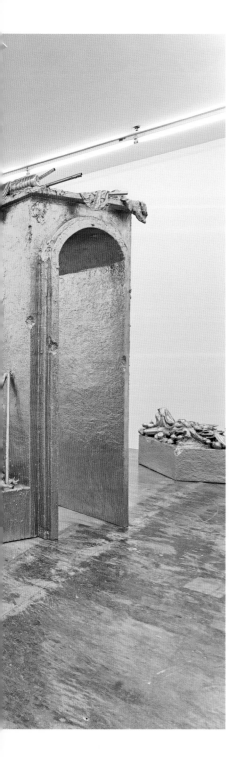

But where does son Jason fit in? He talks of a childhood where his parents included their children in their artistic life, taking them on artist studio visits and to galleries, and discussing art as part of everyday discourse. And this carries through to the present day – the three share an office and spend much of their day talking on the subject.

'Mera brings intuition. I'm more rational and research based. Jason brings a combination of all of these things as well as a phenomenal memory for all the exhibitions he's seen,' explains Don.

So what's next for this collection that is so much the work of an entire family? The next generation, Mera and Don's grandchildren, are already showing signs of having inherited the collecting gene, which should ensure the F-word remains very much in their museum's name – The Rubell Family Collection.

John Miller, *A Refusal to Accept Limits,* 2007; imitation gold leaf on various materials including plastic objects, rope, and plaster on fibreglass forms, twenty elements, variable dimensions. *Previous pages:* Richard Jackson, *The Blue Room,* 2011; fibreglass, steel, wood, Formica, urethane paint, acrylic paint, canvas, wig, motor, rubber, and control panel, variable dimensions.

ART AND COMMERCE

If the eminent art fair **Art Basel** placed Miami on the art map, then the lauded fashion boutique **The Webster** is its fashion counterpart. Founded in 2009 by the Parisian entrepreneur Laure Hériard Dubreuil, The Webster houses avant-garde labels from Maison Margiela to Off-White within its Henry Hohauser–designed walls. Not only a proponent of Art Deco design, The Webster is a bridge between the contemporary fashion and art worlds. We caught up with Hériard Dubreuil to dig a little deeper into how she intertwines her two greatest passions:

Miami has one of the most vibrant art scenes in the United States. Many new galleries and museums have opened in the past five years, and I think Miami is the perfect location for South American and global buyers to look at the art scene, be it established or up and coming.

I opened The Webster in 2009 after spending some time in Miami. The city was not yet on the art map, and I saw an opportunity to create a destination.

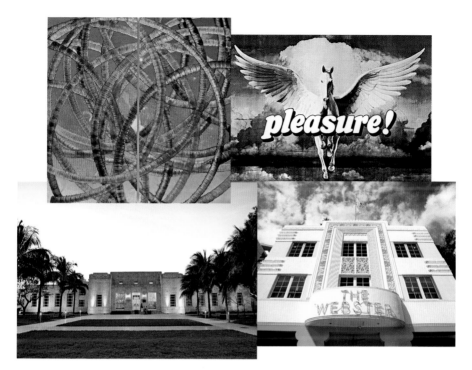

Clockwise from top left: Aaron Young, *SS9 (diptych)*, 2011; FADE burnout/alum. Maxwell Snow, *Untitled (Pleasure)*, 2014; ink and enamel on linen, 266.7 x 152.4 cm. The Webster. The Bass Museum.

I started building an art collection for the boutique with pieces by Joel Meyerowitz, Jen Mazza, Arthur Elgort, Melvin Sokolsky, Louise Dahl-Wolfe, and my husband, Aaron Young.

Fashion and art are always intertwined. During Art Basel we do many events with world-renowned artists. We've celebrated Ryan McGinley and Daniel Arsham, and we did an exclusive Dennis Hopper photo exhibition two years ago. Last year we showcased works by Maxwell Snow and had an exclusive capsule collection of his clothing line.

I am very fortunate as my husband is an artist. Art is Aaron's world and passion, so I find myself in the loop of it. Sometimes I discover new talent at a gallery opening, a museum exhibition, a studio visit, or an art fair. In Miami, I go to all the museums, from the **Bass Museum** to the **Pérez** and **ICA,** as well as the **Rubell** or **de la Cruz** family collections.

FARFETCH CURATES ART DIRECTORY

AUSTRALIA

INSIDE AUSTRALIA
Lake Ballard
Western Australia 6436
lakeballard.com
Tel: +61 8 9024 2702

BELGIUM

■ **SMETS PREMIUM STORE BRUSSELS**
Chaussée de Louvain
650-652
B-1030 Bruxelles
Tel: +32 2 325 12 30
smets.lu

BRAZIL

CENTRO DE ARTE CONTEMPORÂNEA INHOTIM
Rua B, 20
Centro, Brumadinho
Minas Gerais
Tel: +55 31 3571 9700
inhotim.org.br

GALERIA LUISA STRINA
Rua Padre João Manuel, 755
Jardim Paulista, São Paulo
Tel: +55 11 3088 2471
galerialuisastrina.com.br

MENDES WOOD
Rua da Consolação, 3358
Jardins, São Paulo
Tel: +55 11 3081 1735
mendeswooddm.com

SP-ARTE
sp-arte.com/en

CHINA

CAOCHANGDI ART VILLAGE
Chaoyang, Beijing

CHINA GUARDIAN
2-603 Henderson Center
18 Jianguomennei St
Beijing 100005
Tel: +86 10 6518 2315
english.cguardian.com

LONG MARCH SPACE
4 Jiuxianqiao Rd
Chaoyang, Beijing
Tel: +86 10 5978 9768
longmarchspace.com

UCCA
798 Art District,
4 Jiuxianqiao Rd
Chaoyang, Beijing
Tel: +86 10 5780 0200
ucca.org.cn/en

CYPRUS

■■ **BLACK CELEBRATION**
Kypranoros 17A
1061 Nicosia
Tel: +357 22767688

DENMARK

■■ **HENRIK VIBSKOV**
Krystalgade 6
1172 Copenhagen
Tel: +45 33 14 61 00
henrikvibskov.com

FRANCE

■■ **SPREE**
16 rue la Vieuville
75018 Paris
Tel: +33 1 42 23 41 40
spree.fr

GERMANY

■■ **ANDREAS MURKUDIS**
Potsdamer Strasse 81E
10785 Berlin
Tel: +49 30 680 798 306
andreasmurkudis.com

■■ **HAYASHI SHOP**
Boersenplatz 13-15
60313 Frankfurt am Main
Tel: +49 69 219 972 55
hayashi-shop.com

INDIA

DEVI ART FOUNDATION
Sirpur House, sector 44,
plot 39
Gurgaon, Haryana 122003
Tel: +91 124 488 8177
deviartfoundation.org

KHOJ INTERNATIONAL ARTISTS' ASSOCIATION
S-17, Khirkee Extension
New Delhi 110017
Tel: +91 11 6565 5873
khojworkshop.org

LADO SARAI VILLAGE
Mehrauli
Delhi 110030

SARAI
29 Rajpur Road
Civil Lines, Delhi 110054
Tel: +91 11 2394 2199
sarai.net

ITALY

■■ **SLAM JAM**
Via Canonica 12, INT. 3/5
44121 Ferrara
Tel: +39 0532 251211
slamjam.com

■ **TIZIANA FAUSTI**
Piazza Dante Alighieri
24121 Bergamo
Tel: +39 035 224142
tizianafausti.com

■■ **WOK-STORE**
Viale Col di Lana, 5
20136 Milan
Tel: +39 02 89829700

JAPAN

BENESSE ART SITE
Naoshima, Kagawa
benesse-artsite.jp/en

BENESSE HOUSE
Gotanji, Naoshima, Kagawa
Tel: +81 87 892 3223
benesse-artsite.jp/en/
benessehouse

LUXEMBOURG

■ **SMETS CONCEPT STORE**
262 rte d'Arlon
8010 Strassen
Tel: +352 31 07 71 240
smets.lu

STEMS
6 Avenue de la Porte Neuve
2227 Luxembourg
Tel: +352 31 07 71 414
smets.lu

MONACO

■■ **MCMARKET MONACO**
3-11 Avenue des Spélugues
98000 Monaco
Tel: +377 97 97 12 12
mcmarket.mc

NORWAY

THE NATIONAL MUSEUM
Multiple locations, Oslo
Tel: +47 21 98 20 00
nasjonalmuseet.no/en

POLAND

■■ **VITKAC**
BRACKA 9
00-501 Warsaw
Tel: +48 22 310 73 13
vitkac.com

PORTUGAL

■■ **WRONG WEATHER**
Avenida da Boavista 754
4100-111 Porto
Tel: +351 22 605 3929
wrongweather.net

SOUTH AFRICA

BRAAMFONTEIN
braamfontein.org.za

JOBURG ART FAIR
fnbjoburgartfair.co.za

STEVENSON
62 Juta St, Braamfontein
Johannesburg, 2001
Tel: +27 11 403 1055
stevenson.info

WITS ART MUSEUM
1 Bertha and Jorissen St
Johannesburg, 2000
Tel: +27 11 717 1365
wits.ac.za/wam

SPAIN

■■ **ARROPAME**
Calle Villarias, 5
48001 Bilbao, Bizkaia
Tel: +34 944 25 60 76

TURKEY

ARTER
İstiklal Cad. No 211
Beyoğlu 34433 Istanbul
Tel: +90 212 708 58 00
arter.org.tr

CONTEMPORARY ISTANBUL
contemporaryistanbul.com

FARFETCH CURATES ART DIRECTORY

DEPO
Tütün Deposu Lüleci
Hendek Caddesi No 12
Tophane 34425 Istanbul
Tel: +90 212 292 39 56
depoistanbul.net

U.K.

**BARBARA HEPWORTH
MUSEUM AND
SCULPTURE GARDEN**
Barnoon Hill, Saint Ives
Cornwall TR26 1AD
Tel: +44 1736 796 226
barbarahepworth.org.uk/
st-ives

COSKUN
coskunfineart.com

■■ **HERVIA BAZAAR**
40 Spring Gardens
Manchester M2 1EN
Tel: +44 161 835 2777
hervia.com

■■ **LALI SHOP**
101 Golborne Rd
London W10 5NL
Tel: +44 20 8964 1177
lalishop.co.uk

■■ **PRIMITIVE LONDON**
primitivelondon.co.uk

**SOUTH LONDON
GALLERY**
65-67 Peckham Rd
London SE5 8UH
Tel: +44 20 7703 6120
southlondongallery.org

**STUDIO VOLTAIRE &
HOUSE OF VOLTAIRE**
1A Nelson's Row
London SW4 7JR
Tel: +44 20 7622 1294
studiovoltaire.org

WHITE CUBE
144-152 Bermondsey St
London SE1 3TQ
Tel: +44 20 7930 5373
whitecube.com

U.S.

**ART BASEL MIAMI
BEACH**
artbasel.com/miami-beach

A-Z WEST
zittel.org/work/a-z-west

BASS MUSEUM OF ART
2100 Collins Ave
Miami Beach, Florida
33139
Tel: +1 305 673 7530
bassmuseum.org

THE BROAD MUSEUM
221 S Grand Ave
Los Angeles, California
90012
Tel: +1 213 232 6220
thebroad.org

CREATIVE TIME
creativetime.org

DEITCH PROJECTS
18 Wooster St
New York, New York
10013
Tel: +1 212 343 7300
deitch.com

**DE LA CRUZ
COLLECTION**
23 NE 41st St
Miami, Florida 33137
Tel: +1 305 576 6112
delacruzcollection.org

DOUBLE NEGATIVE
Carp Elgin Rd
Clark, Nevada
doublenegative.tarasen.net

■■ **FORTY FIVE TEN**
4510 McKinney Ave
Dallas, Texas 75205
Tel: +1 214 559 4510
fortyfiveten.com

■■ **GALLERY AESTHETE**
46 E Oak St
Chicago, Illinois 60611
Tel: +1 312 265 1883

GRAND PARK
200 N Grand Ave
Los Angeles, California
90012
grandparkla.org

ICA MIAMI
Miami Design District
4040 NE 2nd Ave
Miami, Florida 33137
Tel: +1 305 901 5272
icamiami.org

JUST ONE EYE
7000 Romaine St
Los Angeles, California
90038
Tel: +1 888 563 6858
justoneeye.com

LACMA
5905 Wilshire Blvd
Los Angeles, California
90036
Tel: +1 323 857 6010
lacma.org

MASS MoCA
87 Marshall St
North Adams,
Massachusetts 01247
Tel: +1 413 664 4481
massmoca.org

MOCA
152 N Central Ave
Los Angeles, California
90012
Tel: +1 213 626 6222
moca.org

MoMA
11 W 53rd St
New York, New York
10019
Tel: +1 212 708 9400
moma.org

NADA
Tel: +1 212 594 0883
newartdealers.org

NOGUCHI MUSEUM
9-01 33rd Rd
Long Island City, New York
11106
Tel: +1 718 204 7088
noguchi.org

■■ **ODD**
164 Ludlow St
New York, New York
10002
Tel: +1 646 559 0406
odd-style.com

**PARIS PHOTO LOS
ANGELES**
parisphoto.com/losangeles

PARTICIPANT INC.
253 E Houston St, No 1
New York, New York
10002
Tel: +1 212 254 4334
participantinc.org

**THE PÉREZ ART
MUSEUM**
1103 Biscayne Blvd
Miami, Florida 33132
Tel: +1 305 375 3000
pamm.org

PIONEER WORKS
159 Pioneer St
Brooklyn, New York 11231
Tel: +1 718 596 3001
pioneerworks.org

**RUBELL FAMILY
COLLECTION**
95 NW 29th St
Miami, Florida 33127
Tel: +1 305 573 6090
rfc.museum

THE WEBSTER
1220 Collins Ave
Miami Beach, Florida
33139
Tel: +1 305 674 7899
thewebstermiami.com

■ Indicates Farfetch
Boutiques
■ Indicates Farfetch
Boutiques That
Carry Art

FARFETCH
CURATES ART

EDITORIAL

Editorial Director Stephanie Horton
Editor in Chief Paul Brine **Features Editor** Laura Hawkins
Fashion Features Editor Alannah Sparks **Sub Editor** Jason Dike
Editorial Consultants Fran Gavin, John Matthew Gilligan

ART

Creative Director Peter Stitson **Art Editor** Craig McCarthy **Picture Editor** Robin Key

CURATORS

Grace Banks, Emma Reeves, Skye Sherwin, Eli Sudbrack, Hikari Yokoyama

PICTURES

Artist in Residence pages 6-13: Thomas Giddings; pages 7-9: Eli Sudbrack wears shirt by Liam Hodges, tracksuit bottoms by Y3; page 15 (left): Elizabeth Felicella

The Collectors pages 16-17: Benjamin McMahon; pages 18-19: Wade Griffith; pages 20-23: Jonathan Frantini; pages 24-25: Gaia Cambiaggi

Hikari's Guide to Buying Art pages 27-28: Benjamin McMahon; page 27: Hikari wears skirt by Peter Pilotto, rollneck by Hussein Chalayan, brogues by Coliac, earrings by Ruifier London, ring by Maria Black; page 28: Hikari wears jumpsuit by Roksanda, rollneck by Rosetta Getty, heels by Nicholas Kirkwood, rings by Ruifier London and Maria Black; page 30: © Damien Hirst and Science Ltd. All rights reserved/ DACS, London/ARS, NY 2015

The New Art Capitals page 35 (bottom right): Edouard Fraipont; page 39 (top): courtesy Long March Space; page 41 (top): Servet Dilber, courtesy Gallerie Barbara Weiss; pages 42 (top) and 43 (bottom): courtesy Robin Rhode and Lehmann Maupin

Art Off the Beaten Path pages 44-45: photo © Trevor Mogg/Alamy; page 46 (top left): Osamu Watanabe; page 46 (bottom left): Tadasu Yamamoto; page 47 (bottom): Shigeo Anza; pages 48-49: © Andrea Zittel, courtesy Sadie Coles HQ, London; pages 52-53: © Anthony Gormley, photo by Ingo Oeland/Alamy; pages 54-55: Rossana Magri

LA Confidential pages 56-59, 66-67: Joe Schmelzer; pages 60-61: Melanie Schiff, courtesy Sterling Ruby Studio; page 67: Lanka Tattersall clothing courtesy of H.Lorenzo boutique

The Virtual As Reality page 74: Matthew Gamber; page 76: courtesy American Medium Gallery; page 77: Jessie Askinazi

The Collaborators pages 78-81: Benjamin McMahon

We Are Family pages 2, 82-91: courtesy Rubell Family Collection, Miami

Art and Commerce pages 92, 93 (bottom right): Camilo Rios

WORDS

Artist in Residence, The Collectors, Hikari's Guide to Buying Art, The Collaborators, Art and Commerce Laura Hawkins
The New Art Capitals Skye Sherwin
Art Off the Beaten Path, We Are Family Paul Brine
LA Confidential Emma Reeves
The Virtual as Reality Grace Banks

© 2015 Assouline Publishing
601 West 26th Street, 18th floor, New York, NY 10001, USA
Tel.: 212-989-6769 Fax: 212-647-0005
assouline.com
Printed in China.
ISBN: 9781614284482

FARFETCH
Harella House
90-98 Goswell Rd
London
EC1V 7DF
curates@farfetch.com